The author at his press illustrating the manner in which the printing roller is held while the stone is being inked for an impression

CREATIVE
LITHOGRAPHY

AND HOW TO DO IT

by

GRANT ARNOLD

DOVER PUBLICATIONS, INC.
NEW YORK NEW YORK

Published in Canada by General Publishing Company, Ltd., 30 Lesmill Road, Don Mills, Toronto, Ontario.
Published in the United Kingdom by Constable and Company, Ltd., 10 Orange Street, London W. C. 2.

This Dover edition, first published in 1964, is an unabridged republication of the work first published by Harper & Brothers in 1941, and is published by special arrangement with Harper & Row.
The publisher wishes to thank the Miami University Library, Oxford, Ohio, for making a copy of the first edition available for reproduction purposes.

International Standard Book Number: 0-486-21208-4

Library of Congress Catalog Card Number: 64-20878

Manufactured in the United States of America

Dover Publications, Inc.
180 Varick Street
New York 14, N. Y.

To

Jenny Arnold

whose keen interest in my work is
a constant incentive and inspiration

CONTENTS

PREFACE

Lithography is one of the most interesting of the graphic media for artists. It fulfills all the requirements of a vehicle suitable for creative expression and has the tradition of fine arts as its background as is evidenced by the work of Goya, Delacroix, Daumier, Gavarni, Isabey, Forain, Corot, Menzel, Bonington, Whistler, Brown, Bellows, and other fine artists of the past and present.

Artistically, lithography steadily grew from roots that were offshoots of the need for commercial reproduction of pictures for illustrations, starting soon after the invention of the process, and culminating its first great period of artistic importance with the brilliant creative work of Daumier, Gavarni, and Géricault. Toward the end of this great period (about 1850) known as the "Golden Age of Lithography," the medium fell from its high place as a means of creative expression and declined into a method used by reproductive artists to copy the original work of others onto stone. Except for a few isolated cases, lithography remained in their hands until Toulouse-Lautrec, Redon, Whistler, Pennell, Bolton Brown, and other artists began to take an interest in drawing and printing on stone. Both Joseph Pennell and Bolton Brown, working independently, studied

the technique of drawing and printing creative lithographs, making many experiments to re-establish the drawing and printing methods for creative use. Their efforts and those of their students resulted in a tremendous surge of interest in creative lithography in the United States and it is said that another "Golden Age" is having its beginning through the efforts of American artists. The creative lithographs of Whistler, Pennell, Bolton Brown, George Bellows, Emil Ganso, Kuniyoshi, Ernest Fiene, Charles Locke, Adolf Dehn, Mabel Dwight, Stow Wengenroth, and hundreds of other "Moderns" too numerous to mention here, are indicative of the importance of creative lithography in Modern Art.

It is interesting to note that, while the sources of etching and wood engraving are problematical, lithography has a complete history. We know that it was invented by Alois Senefelder of Bavaria in 1798 and that it differed from all other known methods of printing by making use of the chemical principle that oil and water will not mix. This principle as used by creative artists is simply this. The artist draws on a grained limestone with a greasy crayon. Every place where he touches the crayon on the stone will take color when the stone is inked. Every other place will remain white. This is possible because, before the stone is inked, it is covered with a thin film of water. The printing roller is then charged with a greasy ink. This ink is rolled onto the design through the water film. The water film, which will not stay on a greasy surface, leaves the drawn areas

of the stone and collects on the undrawn areas. When the printing roller establishes contact with the stone, the greasy ink is attracted to the grease that is present on the drawn areas of the stone, and at the same time, it is repelled from the undrawn areas because water repels grease.

The commercial possibilities of Senefelder's invention were so great that within a few years of its discovery, presses were operating throughout the world. The use of steam and electric power made possible the construction of high-speed presses, and the development of photolithography and offset lithography have made the process an important branch of the printing industry.

To the artist remains the heritage of lithography as a fine art in the sense that his hand-proved prints can come into being only by his creative vision, skill, and craftsmanship.

The purpose of this volume is to set forth the elements of lithography step by step, and to demonstrate the principles particularly suited to the needs of the artist. While it is designed for those who have yet to make their first lithograph, it will also be of value to artists engaged in printmaking.

The methods discussed are based on notes taken during class criticism and from the problems and questions that have arisen in the studio.

The author has actively practiced lithography over a period of ten years as artist, printer, and instructor and has introduced over six hundred artists, educators, and students to the craft.

While there are many variations based on fundamental procedure, the methods here stated have been found the most practical and effective not only for primary work but also for advanced technique. Careful observance of directions will invariably produce good results as they have been tried, tested, and found to be efficacious.

Although lithography has been used for many years by artists, the question is frequently asked "Just what is a lithograph?" It would be well at this point to give a definition.

A lithograph is a work of art drawn on a lithograph stone and printed from the same stone on which it was drawn. Prints taken from the stone are known as "original lithographs" and fall into the same category of prints as do etchings and wood engravings. Lithographs differ from etchings and wood engravings in one important respect. They are not bitten into the stone nor is the stone cut away. Work is drawn on the grained surface of the stone with a lithograph pencil or crayon. When the design is completed, the stone is treated chemically and the prints are taken from the chemically prepared surface.

The lithograph stone is stressed in this volume as it is the preferred medium for the artist working in lithography. Lithographs may also be made on lithographic zinc and aluminum plates. Paper may be used also. Drawings made on zinc and aluminum plates are printed directly from the plates in a manner similar to stone. Drawings made on paper cannot be printed directly from

paper. The drawing must first be transferred by litho-graphic processes to either stone or metal plate and the resulting prints are considered to be original lithographs.

Color lithography is done on either stone, zinc, or aluminum plates. A separate stone or plate is needed for each color. Each of the color stones or plates is printed on paper, one at a time, and the resulting combination of the colors on the paper makes a color lithograph. The number of plates needed for printing in color varies with the desire of each artist. As few as two stones or plates can be used to make a color lithograph. The number of color stones can be augmented to carry out the color ideas of the artist. In the graphic art section of the Smithsonian Institution in Washington, D. C., there is a lithograph, produced as a commercial product, that had the record-breaking number of seventy-six color stones used in making the completed lithograph.

A question frequently asked about creative lithography is "How many prints can you get from a stone?" Commercial printers, when asked this question by the author, have stated that "in the old days (about forty years ago), when we hand printed from stone, we often obtained fifty thousand impressions." This statement may be an exaggeration but it is a known fact that thousands of good prints can be taken from a stone, depending on the skill of the lithographer who prints them, the way the stone has been drawn and etched, and the methods used to preserve the drawing on the stone when it is not in use. However, for all practical purposes, the modern artist, who prints his own work, seldom requires

more than twenty-five to fifty fine impressions, and this number is quite within the realm of possibility for every artist lithographer.

A list of materials used by artists in making lithographs will be found on a separate page and each chapter heading has a list of the materials that are discussed in the chapter.

As the materials used in lithography cannot be obtained everywhere, the author has included in the text names and addresses of firms that deal in lithographic supplies.

This has been done so that the reader will save time and trouble in searching for proper supplies.

May 22, 1941 G. A.

Creative Lithography

AND HOW TO DO IT

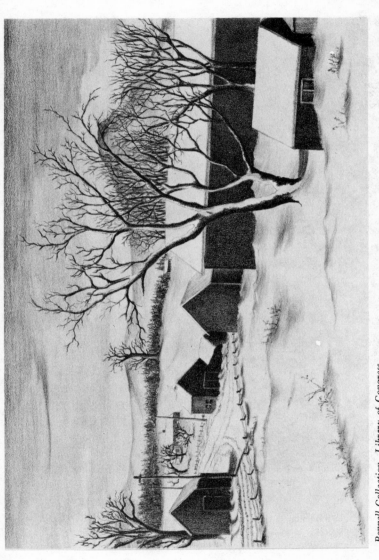

Grant Arnold

MOUNTAIN CROSSROADS

This is a crayon lithograph, drawn on stone, illustrating the possibilities of tonal quality through utilization of the grain on the stone. (See page 23, Chapter III)

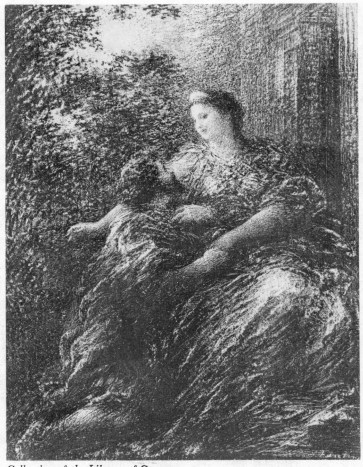

Collection of the Library of Congress

NUIT D'EXTASE Henri Fantin-Latour

All the light modeling in this romantic lithograph on stone was obtained by
scraping. The crayon was heavily applied. (See pages 25 and 26)

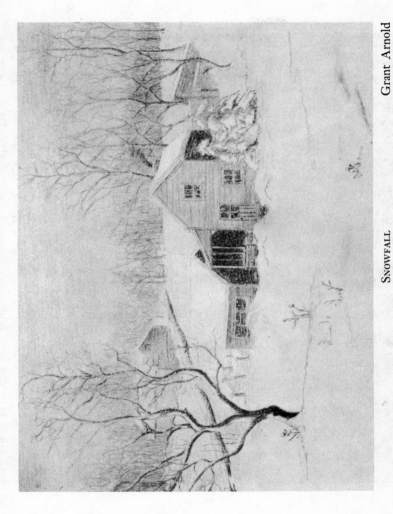

SNOWFALL Grant Arnold

The effect of falling snow in this print was produced by bouncing the blade of a jack knife over the stone's surface after the drawing had been made with crayon. (See page 25, Chapter III)

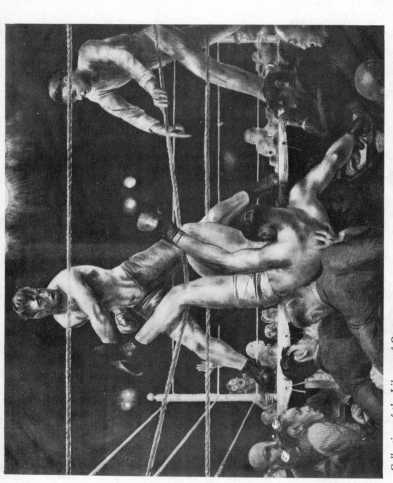

DEMPSEY AND FIRPO George Bellows

This famous lithograph illustrates an exciting use of crayon, tusche and scraping. The light streak behind the standing fighter in this impression was caused by an accidental halting of the printing action while the stone was being run through the press. (See pages 18, 25, 124, 133)

OPUS I. No. 1 Grant Arnold

Combination drawing on stone with tusche, crayon and scraping. (See Chapter III and page 133, Chapter XI)

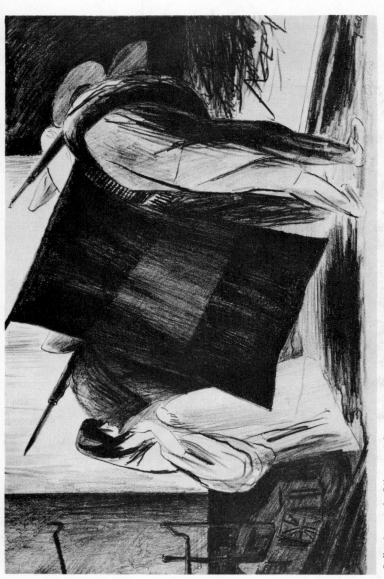

THE FLAG José C. Orozco

This lithograph was drawn on a zinc plate with crayon and tusche. An excellent example of the drawing possibilities of metal plate lithography. (See Chapter XII)

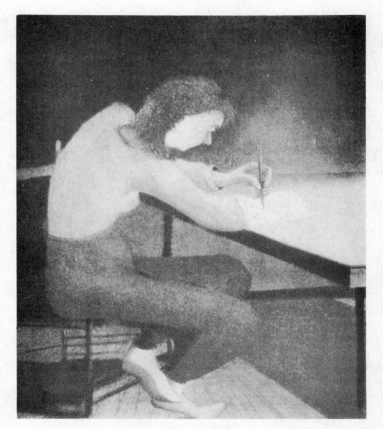

THE WHITE SOCKS Grant Arnold

The background for this lithograph was produced by rubbing pulverized crayon directly on the stone. The tones in the figure were drawn with crayon and then rubbed with felt. (See *Rubbed Lithographs*, page 138, Chapter XI)

WOMEN TALKING Käthe Kollwitz

With this lithograph Käthe Kollwitz demonstrates the freedom that is possible when a dull point and the side of the crayon are used on stone. (See Chapter III, page 18)

Collection of the Library of Congress

UNE RECEPTION H. Daumier

Crayon, tusche and scraping in combination was often Daumier's most favored method of drawing on stone. Note the importance of the tusche accents and the scraping in this lithograph. (See Chapter III, pages 18, 26; Chapter XI, page 133)

STREET SCENE Grant Arnold

The drawing for this print was made on paper with lithographic crayon, transferred to stone by lithographic proc-
esses, etched, inked and printed. (See *The Transfer Lithograph*, page 129, Chapter XI)

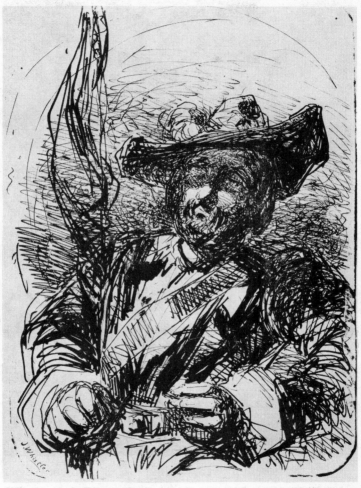

Collection of the Library of Congress James McNeill Whistler

THE STANDARD BEARER

This lithograph was drawn with pen and tusche on stone. Note the variety
of the ink lines. (See page 133)

STUDY IN BLACK Grant Arnold

This lithograph was made on stone by coating the stone's surface with tusche through which the lines were scraped with an engraving needle. (See *The Mezzotint Lithograph*, page 141, Chapter XI)

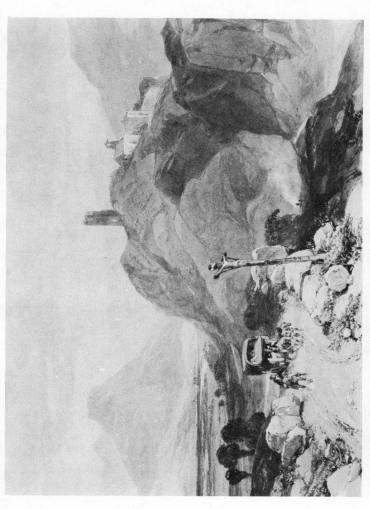

Collection of the Library of Congress

La Tour Sans Denin J. D. Harding

Printed by Hullmandel, using his own process. This lithotint by Harding is one of the finest technical examples of this particular use of lithography. The entire drawing was executed with tusche washes of different degrees of dilution. (See page 135)

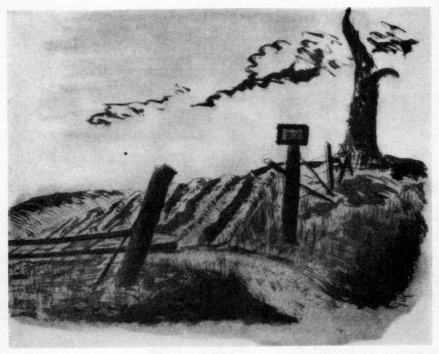

HANGMAN'S TREE Grant Arnold

Lithotint on stone printed by Hullmandel's process. The entire stone was washed with a
light dilution of tusche with turpentine and a drop of linseed oil as a conveying medium.
The dried wash tint was then rubbed with flannel and the drawing was made with several
washes of tusche with turpentine as a medium. (See *Wash Drawings* [Lithotints], page 135,
Chapter XI)

Collection of the Library of Congress

Côte de Douvres Eugene Isabey

A particularly fine example of a mezzotint lithograph on stone. Note the many tonal gradations from black to white which effectively show what can be done with scraping tools. (See page 141)

Grant Arnold

RAILROAD AVENUE

This lithograph is a combination crayon and rubbed lithograph drawn on stone with crayon and rubbed with pulverized crayon and a felt pad. The whites were scraped in with a razor blade. (See Chapter III and page 138, Chapter XI)

I

The Lithograph Stone

MATERIALS NEEDED FOR GRAINING THE STONE:

2 blue-gray lithograph stones, size 12 x 16 inches
Graining stand or table
Carborundum powder, #180, #200, #F, 1 lb. each
Schumacher brick or pumice stone
One file, 16 x 1 inches with handle
1 hand fan
Apron or smock
Teaspoon

The lithograph stone is a natural limestone. It is hard and brittle and is quarried in Bavaria. The best stones for use by artists are blue-gray in color. A good size for beginners is a stone 12 x 16 inches in size and at least two inches thick. Stones this size will take a drawing as large as 9½ x 13 inches. Stones thinner than two inches in thickness are likely to break in printing. Most lithograph stones have a few thin lines in them that look like cracks. These are natural veins made in the strata when the stones were formed by nature. They generally cause no trouble. Occasionally a stone has a vein that will

print across the finished print. Stones that do this should be discarded. However, it is a rare occurrence.

Lithograph stones are purchased from lithograph supply houses[1] and may be bought second-hand. Second-hand stones are just as good as new stones and are much less expensive. When ordering stones, specify size and thickness, blue-gray in color, and insist on a special selection for perfect stones. You should also have the dealer plane the old work from the stone. This is done by a large planing machine that not only takes the old work from the stone but also makes the stone absolutely even. Inform your dealer that the stones you are purchasing are to be used for fine artistic crayon work and that you will consider only the best. The dealer will know what you want and will send you the best he has. It is important to know that after an edition of prints has been taken from the stone, the stone may be regrained by the artist and used over and over again for many editions of prints.

The next step to consider is how to grain a stone. When you receive the planed stones from the dealer be sure to grain them carefully before you draw on them. The stone must be grained to eliminate the planing machine marks and also to surface the stone for the crayon drawing. As we now have the stones, we must find something to grain them on. A flat kitchen table can be used effectively but, as we need water to grain with, an arrangement should be made to catch the

[1] See note at the end of this chapter.

sludge and water that always accompany graining a stone. A flat table can be used out-of-doors without much mess but, if the stones are to be ground indoors, a graining stand may be constructed as follows:

Four legs of 4 x 4 inch wood, 34 inches high hold a box 24 x 30 inches about 10 inches deep at the high end, and about 7 inches deep at the low end. The box should either be painted with deck paint to prevent leaks or may be lined with zinc. In the center of the bottom of the box, about 3 inches from the low end, a hole should be bored and fitted with a length of hose. The hose can be connected with a drain, run out-of-doors, or into a pail to collect the water and used carborundum. The box should have a rim of 2 x 2 inch board on the inside of each of the two 30-inch sides, two inches from the top of the box. Four or five slats of 2 x 2 inch board should be cut to fit across the narrow width of the box. The stones rest on these slats while being grained and as the slats are not to be nailed down, it is easy to keep the box clean (see drawing).

Sea sand, flint,[2] quartz powder,[2] or carborundum can be used as abrasives for graining the stone. Carborundum powder is the best to use as it cuts quicker and ensures an even grain. The suggested grains are #180 (coarse), #220 (medium), and #F (fine). These grains may be obtained in 1-pound, 5-pound, and 10-pound quantities. It is suggested that 1-pound cans be used until the student determines which grain is best for his work.

[2] See note at end of this chapter.

Before graining the stones, take a piece of lithograph crayon and mark the back of the large flat surface of one stone with the numeral 1 and the other stone with the numeral 2. These numerals should be placed on one

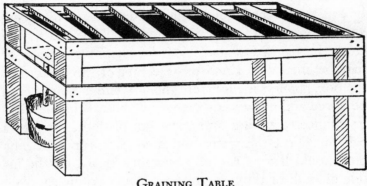

GRAINING TABLE

surface of each stone only. With the stone identified, we can begin to grain them by placing stone No. 1 on the graining stand with the blank surface up. Place stone No. 2 on the graining stand near at hand so that it can be picked up easily. Then wet the blank surfaces of both stones with water by pouring the water over them. Open the can of #180 carborundum and with the teaspoon take a level teaspoon of carborundum from the can.

Sprinkle the teaspoonful of carborundum onto the wet blank surface of stone No. 1 and place stone No. 2 on top of stone No. 1, number side up and wet side down. We now have the two wet surfaces of the stone together like a sandwich with the carborundum as the

filling. (Before beginning to grain, put the can of car-
borundum some place where it will not be knocked
over.) Do not let the stones stand for any length of
time after the wet surfaces have been placed together.
Begin graining at once by grasping the top stone (No.
2) with the left hand at the left top corner of the stone
and the right hand grasping the right lower corner of
the stone, nearest the body. Slowly revolve the top
stone in a circular figure-eight motion, pulling the left
hand toward the body and pushing the right hand
away. Continue this until you have attained a very
rhythmic and easy motion. Take care that the upper
stone goes over the corners of the lower stone at every
turn of the upper stone. It must be understood that only
the upper stone is moved during the graining. The lower
stone is always stationary. After a bit of practice, you
will find that the fingers exert pressure on the corners
of the stone mostly with the forefinger and thumb of
each hand.

During the graining you will notice that the dark-
gray carborundum, by mixture with the ground par-
ticles of stone, becomes lighter in color until it is almost
white. This shows that the carborundum is graining the
stone. You do not need to press down on the upper
stone when graining because the weight of the stone
itself exerts sufficient pressure. Continue the figure-
eight motion of graining until the upper stone begins to
move with difficulty. When this happens, as it will do in
about four minutes, maneuver the upper stone one-
fourth of the way off the lower stone. Then with both

hands, carefully lift it and set on the graining stand numeral surface down, wet surface up.

With plenty of cool water, clean the combination of wet stone dust and carborundum from both stones. After the stones are washed clean, place stone No. 2 face up on the graining stand, sprinkle it with carborundum and place stone No. 1, wet surface down, on top of it. You will notice that we have reversed the stones and will now do the graining with stone No. 2. Stone No. 1 will remain stationary on ·the stand. Proceed as before and remember to change the position of the stones after each cleaning of stone dust and carborundum.

Stones that have just been planed require from four to six grainings to eradicate the marks of the planing machine. The change of position of the stones is necessary because repeated graining with the same stone on top will make the top stone concave and the lower stone convex. This is not noticeable to the eye but can readily be detected by laying a straightedge on the surface of the stones. By alternating the stones, as stated above, they will stay true and not cause trouble in printing. A concave or convex stone will break more easily than a true one when it is run through the press.

The #180 carborundum grain can be drawn upon but, if a finer grain is wanted, grain #220 may be used after you have finished with the #180. When changing grains be sure that both stones are thoroughly cleansed, for the coarse grains will scratch the stone when a finer

grain is being used. The same process holds true when changing from #220 to #F or any other grain you use.

In graining old work from the stones, grain as stated above and continue graining until all trace of the old designs is gone from the stones. This means that the graining should be continued after the design in ink has been ground off. You will see that there is still a light design in the stones. This design is part of the chemical surface of the stones and, if not completely eradicated, may cause trouble by portions of it reappearing beneath the new drawing when it is in the process of being printed.

When you think the stones are sufficiently grained, set them on their edges and wash thoroughly with clean cool water. If you set them on a floor or chair, be sure to place a clean sheet of paper under the stones as the wet stones will take dust and perhaps grease by capillary attraction. Do not use printed newspaper to rest the stones on as the ink on the paper is greasy. You may have to grain the stone over again if ink from the newspaper gets on it. Fan the stones dry with a fan constructed as illustrated here.

If you do not wish to make this fan, a palm leaf fan or a piece of thick cardboard about ten inches square will serve the purpose. Be careful not to hit the stones with the fan as this sometimes leaves a mark and the stones will have to be regrained.

After the stones are dry, look at them at an angle toward the light to see if there are any scratches. If there are scratches, grain again until these marks are removed.

It is difficult to observe scratches on the stones when they are wet. The only test is to dry them. After the stones are free from scratches, replace them on the

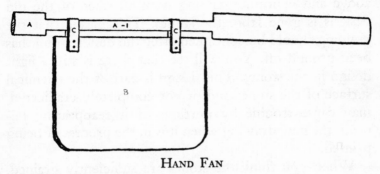

HAND FAN

 A. Piece of broom stick, 15″ long.
A-1. ¼″ cut away each side of stick, 7″ long.
 B. Heavy cardboard, 6″ x 6″.
 C. Leather straps, fastened with brass paper fasteners.

grinding table and wet with clean cold water. Then take the file, which should be about sixteen inches long, including the handle, and one inch wide, and bevel the edges of the stones with about a quarter-inch bevel. (This file can be bought at any hardware store.) The bevel prevents the stones from chipping and helps to keep ink from sticking to the edges while the stones are being printed.

After the filing is done, wash the stone dust from the stones and polish the edges with the Schumacher brick. (Pumice stone can be used instead of Schumacher brick.) Keep polishing until the edges feel smooth to the tips of the fingers. Then wash the stones with water

and dry. When the stones are dry, they are ready for use. If the stones are not to be used at once, cover them separately with a sheet of clean white paper. Never cover stones with oil, wax, or tracing paper. A sheet of clean drawing paper or several sheets of typewriting paper will do nicely. Over this paper it is best to place several thicknesses of clean newspaper or clean wrapping paper to prevent insects or anything else from touching the surface, until you are ready to begin your drawings.

There are two more things to know about graining a stone. The first is an accident that often happens to inexperienced lithographers. Sometimes while graining you may want to rest and will leave the two stones face together after you have been graining a little while. When you begin to grain again, you will be surprised to find that the stones will not separate. Never try to pull them apart by force or hit them with a hammer. Get a thin-bladed table knife and gently force it between the edges of the stones. (You may chip the stones a little when doing this but that cannot be helped.) Then tap the knife with your finger; as soon as a little air gets between the stones they will separate without any trouble. When the water dried, they were held together by suction. Always separate the stones and wash them when they are to be left for a while.

The other thing to know about graining a stone is that two stones are not necessary to do the job. Lithographers sometimes use an instrument called a "levigator." The levigator is a round or sometimes octagonal

disk of steel, ten inches in diameter and two inches thick, with a handle set near the edge by means of which the levigator is rotated over the stone that is being grained (see drawing).

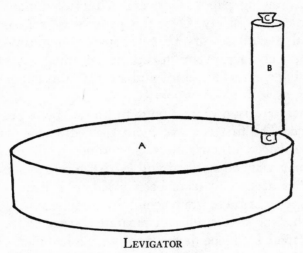

LEVIGATOR

A. Steel Disk—10″ in diameter.
B. Wood or pipe handle, 6″ long, 1″ thick.
C. Steel core.

To grain a stone with the levigator, place the stone on the graining stand, wet with water and sprinkle with carborundum. Use the same amount as in graining two stones. Wet the lower surface of the levigator and place it on the stone. Rotate the handle counterclockwise, and the levigator will turn easily. Do not grain in one place. Keep moving the levigator all over the surface of the stone. When the levigator begins to turn hard, slide it off and wash both stone and levigator. Continue as be-

fore. When using the levigator, be sure to stop graining as soon as it begins to work hard. The levigator scratches the stone easily when it does not move freely.

Levigators cannot be purchased from a lithograph supply house. They can be ordered from any machine shop if you show them what you want. They are most useful in graining stones that are larger than 16 x 20 inches.

NOTE: Sea sand is used for coarse graining, flint and quartz powders for finer graining. The sand and quartz powders must be changed more often than carborundum because they break down with the action of graining and produce uneven and flat grains if used too long. In finishing the grain of the stone, always use fresh powder, and stop graining before the powder loses its "tooth." Sea sand and flint and quartz powders can be obtained from lithograph supply houses. They are less expensive than carborundum but do not grain the stone so quickly.

II

Tracing the Drawing on the Stone

MATERIALS NEEDED:

2 sheets nonoily tracing paper
1 hard lead pencil
Stick red conté crayon
1 tablespoon
Scotch tape
Gum arabic solution
Flat water-color brush

We have now reached the point in the making of a lithograph where we have a stone grained and ready for use. If you should want to make a lithograph directly on the stone, you are ready to take a lithograph crayon and start to work. If, however, you have made a sketch on paper and want to use it as a guide in drawing the lithograph, a tracing of the outline is a good thing to have.

The tracing may be made in two ways, depending on whether or not you want your finished lithograph to be

reversed. In printing, the design on the stone is always in reverse of the finished print, and this fact must be kept in mind while making the tracing.

If your subject or composition would not lose in being reversed, an adequate tracing can be made by rubbing a stick of red conté crayon on the back of your original sketch. When you have made an even coating on the back of the sketch, shake the paper a few times to remove excess crayon and carefully place the paper, drawing side up, on the stone. It must be borne in mind that in planning your lithograph, at least 2 inches of margin on all four sides should be left on the stone, to facilitate the operations of drawing and printing. If there is a margin of only ½ to 1 inch, the edges of the stone will usually, even though they are carefully beveled, pick up ink from the printing roller, as you will have to ink the stone right to the edges in order to get a full inking of the design. You may also run into difficulties in setting the scraper while operating the press. With too narrow a margin, the scraper, which must rest on the stone when a proof is pulled, may overlap from the design and cause heavy lines to appear along the edges of the print, making it a wasted proof. To prevent this, you might attempt to set the scraper on the narrow margin when you apply pressure in preparation to running the stone through the press. The scraper will probably slip off the stone, damage the printing tympan by creasing, spoil the printing paper by smudging, and perhaps break the stone.

If, by a lucky chance, you happen to avoid this trou-

ble you will run into similar difficulties when you run the proof. If the other end margin also is too narrow, you may run the scraper off the stone in attempting to get a complete printing. If this happens—and it often does under these circumstances—you will hear a loud crash, indicating the sudden removal of the printing pressure. Stones sometimes break when this happens, and when a stone breaks nothing can be done except to get another stone and begin all over again. All this can be prevented if a full 2-inch margin on the stone is planned for when you make your sketch. This amount of space is sufficient to allow for free handling of the printing roller. It will give the scraper, which takes an inch of space, a good base on which to apply the starting pressure without damage to the design, and it will give a good parking place for the scraper at the other end of the stone when you stop the press and make ready to release the pressure lever after the proof has been run.

Some artists like to gum the margins of the stone before drawing to keep them clean. This can be done either before or after the tracing is on the stone. The method for mixing the gum arabic solution will be found in Chapter IV, "Treatment of the Stone After Drawing Is Completed."

Take a clean flat water-color brush, or a round one if you haven't a flat one, and carefully paint all the margins of the stone with the gum arabic solution. Be sure to dry the solution on the stone before you start to draw. The dried solution prepares the margins against

taking lithograph crayon or ink and will keep them clean while you are drawing. However, it is good practice to leave the margins open so that tryout lines and tones can be made. These can be eliminated after proving the stone.

Red conté crayon is used for tracing because it contains no grease and is chemically inert when used on the lithograph stone or metal plate. Black conté crayon and charcoal may be used for tracings instead of red conté crayon as they, too, are chemically inert, but red is preferred as the black conté crayon and charcoal have the same color as lithograph crayon and may confuse you when drawing on the stone.

If you should want your finished lithograph to have the same structural appearance as your original sketch, your tracing on the stone will have to be in reverse. This can be done by placing your sketch, drawing side up, on a table. Then take a sheet of nonoily tracing paper, place it over the sketch, fasten the papers to the table with Scotch tape, and make your tracing in outline with a sharp-pointed red conté crayon. Oily tracing papers are manufactured by a process of dipping sheets of paper in a bath of penetrating fluid which makes the paper translucent. Nonoily papers are manufactured without the necessity of an oily bath to obtain the translucent quality that is necessary for tracing. Your art supply store can furnish you with nonoily tracing paper. If you should use an oily tracing paper, it might smudge the stone, particularly in warm weather, the stone being extremely sensitive to any oily or greasy

substance. Oily smudges passed from the tracing paper to the stone will usually take color when the stone is printed.

When your tracing is completed, remove the Scotch tape and the sketch, and place the tracing, conté-crayon side down, on the stone. When you do this you will see that the tracing is in reverse of the original sketch. Fasten the tracing to the stone with Scotch tape and rub the back of the tracing, with a circular motion, with the bowl of a spoon. Lift one corner of the tracing occasionally to see if the conté crayon is separating from the tracing paper to the stone. When you are satisfied that a firm, clear outline of crayon has been rubbed onto the stone, remove the Scotch tape and the tracing paper. You should now have on the stone a reversed red conté crayon outline of your original sketch and are ready to start your drawing with the lithograph crayon. If, for some reason, the conté crayon outline on the stone is smudged or otherwise inadequate, the outline may be washed from the stone with cool clean water and a clean sponge or cloth. Dry the stone and make another tracing. The red conté crayon will color the stone a bit after washing out the tracing, but the excess color will do no harm.

Do not use a lead pencil for guidance lines on the stone. Pencils contain graphite, and pencil marks may take color from the printing roller and print in un-wanted places. If your red conté crayon tracing is too heavy, it will prevent the lithograph crayon from ad-hering to the stone, by preventing its grease content

from making contact. This can be overcome by dusting the conté crayon tracing with a wad of loose absorbent cotton. Hold the cotton lightly and use a light lifting motion. Do not rub the tracing on the stone as it may smudge so badly that you may have to do it over.

Instead of rubbing your tracing on the stone with the bowl of a spoon, you can get a sharp, clear tracing by running the tracing paper and the stone through the lithograph press. This method of making a tracing is exactly the same as running a print through the press except that you will be making a conté crayon impression from tracing paper to the stone, instead of taking an inked impression from the stone to the printing paper. Refer to Chapter V for a description of the lithograph press and how to use it.

III

Drawing on the Lithograph Stone

MATERIALS NEEDED:

 Lithographic crayon—Nos. 2, 3, and 4
 Several sheets of drawing paper
 Several sheets of typewriting paper
 Handkerchief
 Sheet of tracing gelatin
 Single-edged razor blades
 Sandpaper
 Crayon holder (portcrayon)
 Scraping tools
 Drawing bridge
 Table

Having completed our tracing in red conté crayon, we are now ready to make our drawing with lithograph crayon. Before we begin actual work, perhaps a brief discussion of lithograph crayons is in order.

Lithograph crayons are obtainable commercially in grades ranging from No. 0, extra soft, to No. 5, extra hard. Grades Nos. 2, 3, and 4, are the best to use for

your first stones, because they are fairly hard and easiest to handle. These commercially made crayons are made of a basic grease content usually formulated with soap, wax, shellac, tallow, and lampblack. Crayons of this type are those most generally used. They are made by Wm. Korn, Inc., New York City, and can be obtained at any lithograph supply house or art supply store.

This type of crayon, first made by Senefelder, the inventor of lithography, is soluble in water. All the ingredients, except lampblack, act on the lithograph stone and lithographic metal plates which are all sensitive to grease. The lampblack, containing no greasy substances, is inert, and is used only to provide a visual means for the artist to see what he is doing. The balance between the chemically active ingredients and the lampblack is so perfect that when a light line or tone is drawn it will print light, and when a dark line or tone is drawn it will print exactly as it appears on the stone.

Reference to the formulas of Senefelder's crayons may be found in his book, *The Invention of Lithography*, J. W. Muller translation, pages 118-121 (The Fuchs & Lang Mfg. Co., New York, 1911).

Owing to the shellac in crayons made from these formulas, the crayons are tacky and some artists do not like to use them. The late Bolton Brown invented a crayon that overcame this difficulty. Bolton Brown's crayons are not manufactured commercially, but his discussions and formulas for soluble and insoluble crayons may be found in his book, *Lithography for Artists*,

pages 16-26 (The Scammon Lectures for 1929, Art Institute of Chicago, Chicago University Press). The crayons are made of hard basic ingredients, chiefly carnauba wax, castile soap, and lampblack. These crayons are not hard to make and are pleasant to use.

Albert W. Barker has recently made an adaptation of the Bolton Brown method of crayon making by using carnauba wax, stearic acid, olive oil, and graphite for his crayons. His formulas for making these crayons can be found in his article "Lithographic Notes" in *Prints* magazine (February, 1937, Vol. VII, No. 3, pp. 139-142).

In order to draw on the stone easily, you should have a table. However, you can set the stone on a strong easel, prop it on a chair, or hold it on your lap. You can work with the stone flat on.the table or you can prop it against a 2-inch block of wood or an old book. For a hand rest, you can make a drawing bridge (see draw-

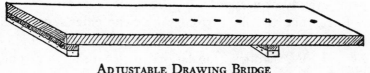

ADJUSTABLE DRAWING BRIDGE

ing) or use a folded sheet of clean drawing or typewriting paper with a folded handkerchief as a pad between the upper and lower faces of the paper. The handkerchief prevents the heat of your hand from melting the crayon on the stone and filling in the tones.

Do not use cloth on the stone to rest your hand. Turkish towels, velvet, silk, and other cloth materials have a tendency to slip under the movement of your hand, and they may make bad smudges. The sad part of this is that the smudges cannot always be noticed while you are drawing, but after the stone has been rolled up in ink, you may find that you have inadvertently rubbed a heavy tone on the stone so badly that corrections are quite impossible.

The drawing bridge can easily be made from a piece of plywood, 3 inches wide and 12 to 14 inches long. Drill a series of ⅛-inch holes, ½ inch apart lengthwise down the center of the board, beginning at one end and ending near the middle. At one of the ends nail or screw a strip of the plywood, 3 inches long and ½ inch wide, across the face of the board to make a fixed lift. The bottom of this lift is to be covered with glued-on felt or cloth. Whittle a peg to fit the drilled holes in the board and drill a hole in another strip of plywood the same size as the first strip, making certain that you do not drill the hole all the way through the strip. Cover the bottom of the strip with glued-on felt or cotton cloth and then glue the peg in the hole. The peg should be long enough to extend through the top of the board so that adjustments can be quickly made. By using a peg arrangement on the second lift you will have a movable lift that makes it possible to shorten or lengthen the bridge. When the bridge is used, a clean sheet of type-

writing paper under each lift will keep the bridge from slipping and injuring the drawing.

Get a comfortable chair to sit in and place conveniently a wad of absorbent cotton, to flick bits of crayon from the stone, crayons for drawing, razor blades, scraping tools, and sheet gelatin for lifting out lines or tones.

You may like to use the crayon in both pencil and stick form. The pencil form resembles a thick lead pencil wound in black paper that can be unwound as used. The stick form comes in boxes of twelve. Each crayon stick has four edges, is ¼ inch square and 2 inches long. A crayon holder is useful when drawing with stick crayon.

Whichever form you use, always sharpen the crayon with a razor blade of the single-edged variety to lessen the danger of cutting your fingers. Hold the crayon in the left hand and sharpen the point toward you to prevent breaking. Crayon shavings may be caught in a small dish. Some artists save the shavings, melt them down in a small iron skillet, cut them to size with a hack saw when cool and use them again. Do this only when you have been consistently using a single grade of crayon. Several grades melted together may produce unpredictable results. It is a good policy to have a number of crayons sharpened when drawing, as a good point is essential for clean tones and sharp lines. A supply of a dozen or more sharpened crayons will save time, as you can discard a used crayon and pick up a fresh one without taking time out to resharpen. Several sheets of

fairly smooth sandpaper (No. oo) kept near by can be used to freshen dull points. This saves time and extends the life of the point.

With all this in mind and at hand, you are ready to begin your drawing. Many people have many theories about how a drawing should be made on stone, but the creative artist is the best judge of how to adapt his creative vision to his medium. A point to bear in mind is that you are drawing on a grained surface and that your crayon adheres to the tops of the grain of the stone. Building up a tone from light to dark, rather than attempting a full tone at one stroke, will usually give a richer printed tone that will survive a good etch and produce more prints. A good way to make a crayon drawing is to begin with a No. 4 crayon and work up to your middle and black tones with Nos. 3 and 2 crayons. It is, of course, perfectly possible to make your entire drawing with light, middle, and black tones and lines by using only the No. 4. You can even do it with the No. 5. In other words, you can use one crayon to make your entire drawing on stone or you can use a combination of them. At the start of your work on stone, I would suggest that you use only the No. 4, in order that you may see how much you can accomplish with just the one grade.

Do not talk to anyone while working on the stone as drops of saliva may fall on the surface; this will cause white spots to appear on the finished print. Saliva has the same reaction on the stone as gum arabic, and this saliva reaction is known as a partial preparation. It

doesn't do the job that gum arabic does, but only makes a nuisance of itself. And scratching your head while working is asking for trouble, for bits of scalp and dandruff falling on the stone will cause black spots to appear when printing. Scalp and dandruff have a tendency to be greasy, and the stone always shows when grease is present.

If you should make errors in drawing, they can be lifted out without injury to the stone by gently warming, with your breath, the surface to be lifted, taking care that no saliva drops on the stone. Place a piece of the sheet gelatin over the part to be corrected. If you do not have gelatin, an underexposed photograph film makes a fairly good substitute. Draw with a hard lead pencil on the gelatin over the area or lines you want to take out. Lift the gelatin and you will see that wherever you have drawn on it a corresponding section of the crayon will have been lifted from the stone to the gelatin. The area will not be so clean as it was before you drew on it with crayon, but it will be quite white and can be worked over without difficulty. The heavier the crayon on the corrected portion the whiter will be the lifted-out lines or area. The gelatin, as you can see, can be useful to create white outlines and to put in lights. After a while the gelatin will become heavy with crayon. You can clean it with turpentine and use it over again after it is dry. When you use gelatin, be sure to place a clean section over the parts of the drawing to be lifted, because gelatin will not pick up crayon if it

already has crayon on it. Lines lifted out with gelatin will print just as they look on the stone.

Other corrections and additions can be made with a razor blade or with scraping or engraving tools. Old dental instruments, which you might be able to beg from your dentist, make splendid scraping tools. Sharpen them to a round or straight edge on an oilstone before using. All scraping tools should be very sharp to prevent sliding and slipping. You can test the point on your thumbnail. If the point slips, it is too dull; if it sticks, it is right to use. Save the use of the razor and scraping tools for the last steps in the drawing, as the grain of the stone is destroyed by this method of correcting. If the crayon is used over the scraped portions, it will have a rough appearance on the print. Should you want a rough texture, you can get it in this way.

You can rub sandpaper over the crayon to get another type of texture on the stone. You may also bounce the blade of a heavy pocketknife of the Boy Scout variety, holding the handle lightly between thumb and forefinger, over the surface of the stone to make a spotted texture.

Unless the scraping, knife jumping, and sandpapering is very deep, it will grain away at the same rate as the drawn parts do when the stone is regrained. Remember that the lithograph stone is intended for drawing. Save your experiments in sculpture for marble or granite. It is bad form to gouge out lines on the stone with icepicks, railroad spikes, and hammer and chisel. The most effective scraping is done gently but firmly,

and need go no deeper into the stone than is required to remove the crayon and produce a clean line.

Drawing with a well-pointed crayon will produce clear tones and lines. As your point gets dull, the lines get broader and the tone gets coarser. If you continue without repointing the crayon, and draw with a back-and-forth motion, applying pressure at the same time, you will notice that at the end of each stroke the crayon will lift some of the tone, leaving a white spot in its wake. The darker the tone the more readily will the crayon lift out white spots. If you want a texture like this, everything is fine. If you want an even tone, you must not scrub with the crayon. Use single strokes, setting and lifting the crayon at the beginning and end of each stroke. Otherwise your lithograph will fill with crayon and you will end up with a much different drawing than you had in mind. If filling in gets too much for you, grain the drawing off the stone and start again. It might, however, be interesting to complete the drawing as best you can and see how it prints.

The crayon itself, as you can see by its tacky qualities, can be used to make corrections. If you want to take out a line without destroying the grain, and the part is too small to get at with gelatin, you can make the correction by placing the point of a crayon on the spot to be lifted. Apply a slight pressure, and lift the crayon quickly.

Another use of the crayon is to cut from a stick a small square piece about ⅛ inch thick, and press it against your forefinger. Rub this "pill" on the stone

with your finger, taking care that your finger does not touch the stone. The texture will be rough, but it is possible to use it effectively. Holding a stick of the flat crayon between thumb and forefinger and drawing a tone with one of the edges, will give a smooth, allover tone the width of the crayon. Apply this type of tone with a slow one-stroke motion. Drawing with the edge in a back-and-forth motion will pick up lines in the tone, and make it difficult to blend the tone without picked-up lines separating the strokes.

Examine the edges of the crayon for nicks before you start a tone. Nicks draw unwanted lines and can be eliminated by smoothing the edges of the crayon with your fingers. If a crayon has too many nicks on its edges, discard it and take a better one.

Before bringing this discussion of drawing on the stone to a close, it may be important to explain that, owing to atmospheric conditions, the stone is subject to sweating. In cold weather, your breath may condense on it and cause a damp area. Do not draw on the damp surface. Fan it dry and then proceed with your drawing. During warm weather, the stone may become damp by itself. This happens when the stone is colder than the surrounding atmosphere. In winter, the stone sometimes sweats when it is warmer than the room. Dampness and sweating always make the affected areas appear darker in color than the rest of the stone. If you suspect the presence of any dampness or sweating, fan the stone until it has the same color all over. Never draw on a

damp spot with crayon as it will partially dissolve and spoil the texture of your tones and lines.

As you draw, you may find it helpful to study your drawing on the stone by viewing your work through a mirror in order to ascertain how your lines and tones will appear in reverse. This is an important procedure, since everything you draw will appear in reverse on the print. You can also help to determine your drawing values by examining your work through a reducing glass.

These methods of drawing with the lithograph crayon will get you well started on your way. Later chapters will discuss additional drawing materials and how to use them.

IV

Treatment of the Stone After Drawing Is Completed

MATERIALS NEEDED:

French chalk (talcum powder)
Several clean rags
1 lb. nitric acid U.S.C.P.
2-inch acid brush
Gum arabic (crushed or lumps)
1 6-ounce graduate
1 small glass or crockery jar (pint size)
1 6-inch pipette
Rubber nipple for pipette
Cheesecloth, 1 yard
Newspaper
Dessert dish
Pointed stick 10 inches long, ½ inch wide
A watch
Sheep's-wool sponge

Let us assume that your drawing on the stone has just been completed and that you are ready to prepare the stone for printing. Between the creative process of

drawing and the craft process of printing lies the important step of preparing the stone for printing. This is known as "etching." Before setting forth the methods, a discussion of etching on the stone is in order.

You have drawn on a grained, clean, unetched stone with a lithograph crayon that is soluble in water. As water is needed in printing, the crayon must be made insoluble in water so that the drawing will not wash off the stone. It is also necessary to keep clean those parts of the stone which have not been touched by the crayon, in order that the white parts of your drawing will print white. It is vital to the success of your print that all the parts of the stone that have been touched by the crayon will take ink in exact proportion to the amount of crayon that has been used, to create light, middle, and black tones or lines. The final objective is so to fix the drawing on the stone that an edition of prints can be taken that faithfully mirror on paper the drawing on the stone. This is known as "etching the stone." There are many ways to do these things. Almost all artist lithographers, and commercial ones too, have favorite methods of etching. Probably no two of them will agree exactly on each step of the etching process, but as all methods of etching that produce good prints are usable, we will not say that any one is best and must be followed. After you have mastered one method, it would be advantageous for you to estimate the possibilities of others for the development and advancement of your creative work in lithography. References to the

etching methods of Senefelder, Bolton Brown, and Albert W. Barker are given at the end of this chapter.

Now to get to work. If your press is at hand, place the stone on the press bed not too near the edge. If your press is not available, use a table strong enough to hold the weight of the stone.

Take a piece of cheesecloth and fold it three or four times until it forms a soft pad, 3 inches square. Put the pad aside for the moment and sprinkle a light layer of powdered French chalk over the drawing on the stone. A good grade of talcum powder can be used instead of French chalk—talcum powder is French chalk with scent added. Do not sprinkle the chalk too heavily. The equivalent of ½ teaspoon should be enough. Take up the cheesecloth pad and lightly brush the French chalk over the stone so that all parts of the drawing will have been coated. You will notice that the chalk adheres to the crayon. Then dust off the excess. French chalk is used on the drawing to make the crayon more acid resistant when the etch is applied, and it can be safely used as it is nongreasy and therefore chemically inert on stone.

The first step in preparing the stone for etching is to make a gum arabic solution. Take a pint glass jar, of the kind used for canning fruit, and into it drop 2 ounces of crushed gum arabic. Use a 6-ounce graduate to measure with. Then measure 2½ ounces of water and pour it over the gum arabic. Stir with a small wooden stick (about 10 inches long) until all the gum arabic is wet. There should be ½ inch of water covering the gum. If

there is more, pour some off. When all the gum arabic has been dissolved, the resulting solution should be about the consistency of thick cream. If too much water is used, the solution will be too thin. You can test the gum by dipping your forefinger into the solution and then pressing it against the ball of your thumb. If the gum solution is right, it will feel smooth, soft, and tacky between your fingers. If too thin, it will feel watery, runny, and not tacky. If the gum is too thick, it will not spread smoothly on the stone and will look lumpy. You can remedy thick gum by adding water, drop by drop, and stirring until a workable consistency is obtained. Thin gum is made usable by adding more crushed gum arabic, stirring until it dissolves. If you are not in a hurry, you can start the gum solution the night before you intend to use it, and by morning it will be ready. Always stir the gum thoroughly before testing. If you want to use a gum solution the same day, use warm water. Stir often, and the gum solution should be ready for use in from one-half to one hour's time.

Gum arabic solution will keep for about two days in a cool temperature. It spoils almost as easily as cream, and when sour is dangerous to use. Fresh gum arabic solution contains a natural gum arabic acid that by itself is capable of preparing the stone for printing. When sour, its natural acid content changes and this change prevents a proper reaction when the solution comes in contact with the stone. If you are at all suspicious of a solution that has been standing for several days, you can test it by smelling and tasting. If it smells sour, and

tastes sour, throw it away. If it smells and tastes sweet, it is right to use. Mix small quantities often. Do not take chances with sour gum arabic solutions.

If you must have in readiness at all times quantities as large as a pint or a quart, bacterial action can be retarded by adding two or three drops of eugenol or carbolic acid to the solution. Do not use this solution after it is more than a week old. Both these preservatives can be purchased at a drugstore.

You will probably have noticed by this time that there are bits of bark and other foreign matter in the gum solution. These are due to dirt and bark that adhered to the gum arabic lumps when they were formed on the acacia trees in Senegal. If you cannot get crushed gum arabic from the supply house, break the lumps before you use the gum. A small iron mortar and pestle is useful for this purpose. Some artists like to use powdered gum arabic purchased at a drugstore. This type of gum arabic is not recommended even though it dissolves quickly. Gum arabic purchased in a drugstore is intended for uses other than lithography, and all gum arabics do not act on the stone in the same way. It would be better to purchase your gum arabic at lithographic supply houses, as their products must always meet with the special requirements of lithographers.

After the gum arabic is dissolved and the solution is of the proper consistency, take another piece of cheesecloth 12 inches square and double it. Place it over the mouth of another clean pint fruit jar. Do not stretch it tightly; allow a sag to form in the center. Pour the gum

arabic solution over the cloth and let it strain through into the jar. If you dampen the cloth with water before pouring the gum solution, the gum will strain through a little faster. The cloth will catch all the dirt. After the solution has been strained, wash the cheesecloth in water. You will be able to use it again for the same purpose.

As we now have dusted the stone with French chalk and have obtained a clean gum arabic solution, our next problem is to mix an etch. The etch will consist of gum arabic solution and nitric acid. This step is, and has been, a great headache with many artist lithographers: If too much acid is used, the delicate lines and tones of the drawing will be eaten away, and the print will look washed out and anemic. If not enough acid is used, the blacks will fill up after a print or two, and the ink will overrun into the parts not supposed to take ink, and a "black as midnight" impression and a ruined stone will be the result. Let us examine the situation and see what we are trying to do before we do it.

We have a lithograph stone with crayon on it. The stone is a form of limestone, and gum arabic and nitric acid will react on it. The gum arabic by itself will not only close the undrawn parts of the stone against grease but it will also unsaponify the crayon and change the ingredients, except the inert lampblack, to insoluble chemical grease spots that become part of the stone's surface. It is possible, after the gum arabic soloution has been applied and dried on the stone, to wash out the crayon with turpentine and roll the stone with ink. The

gum, by itself, will not allow a long run of printing, but it is possible to take a few impressions using gum arabic alone as an etch. Gum arabic is an important part of the etch, but it needs help in preparing the stone to print a reasonable edition of fine prints. We will use the nitric acid to act as a helpmate to the gum arabic, and this is to be done by adding a certain number of drops of nitric acid to the gum arabic solution.

The nitric acid is able to penetrate farther into the stone than gum arabic because of its corrosive action. When the acid is mixed with the gum arabic solution to form an etch it attacks and penetrates the stone, and carries the gum arabic along with it. The gum is, there-fore, aided in carrying its quality deeper into the stone when used with nitric acid than it could do by itself. This combination of nitric acid and gum arabic solution makes it possible to keep the stone clear of ink in the places that have not been touched by the crayon, and to confine and keep it to the chemical printing spots that receive the ink from the printing roller. The nitric acid also completes the change of crayon ingredients from a soluble to an insoluble state.

How are we to determine the amount of acid to be added? As this is the important question in etching a lithograph on stone, let us at this point add some nitric acid to the gum solution to see what happens. Measure 1 ounce of gum solution in the graduate and then pour it into the dessert dish. Then take a pipette with a nipple on it and insert the end of the pipette in the bottle of acid. Use care in opening the acid bottle. Do not be in

a hurry or it may splash and burn you. If you should get acid on you, quickly wash it with quantities of cold water. If the burn is a bad one, call a doctor.

Draw 1 inch of acid into the pipette, place the stopper back in the acid bottle and set it where you will not knock it over. Then carefully drop 25 drops of acid into the gum solution that you have placed in the dessert dish. If any acid remains in the pipette, put it back in the bottle. Place the pipette, nipple end up, in an empty glass jar. An olive jar is a good holder for the pipette. Now take the acid brush, and wet it with water. Drain off as much as you can. The damp acid brush will allow the etch to adhere evenly. Stir and mix the etch with the acid brush so that the acid will be well mixed with the gum solution. After you have done this, press excess etch from the brush against the side of the dish. At this point we have an etch ready for application to the stone and the stone ready to receive the etch. The question is this: Is the etch too strong or too weak? Let us find out. We know that the crayon is acid resistant and that it has been further protected with an acid-resisting dusting of French chalk. We know that the crayon is on the tips of the grains that we put on the stone, and that these grains resemble tiny mountaintops, while the valleys are protected only by the dusting of French chalk. We must now find out how the naked stone reacts to the etch we have mixed. If it is too strong, it will melt away the mountaintops by attacking the bases, and so spoil the tone of the drawing. If too weak, the etch will not fix the ingredients of the crayon where they belong

and, in printing, the chemical printing spots on the mountain peaks will slide into the valleys and fill them with ink after a few prints have been pulled. An etch that reacts favorably on the naked stone will usually etch the drawing properly.

Take the acid brush, dip the tip a little way in the etch, and apply to an area of 1 inch on the margin of the stone that is nearest to you, taking great care not to carry the brush over the drawing on the stone. Brush the etch on the selected marginal area.

Observe carefully the reaction of the etch on the stone. The nitric acid in the etch will attack the lime in the stone, and carbon will be released in the form of a gas, causing an effervescence to appear in the form of tiny bubbles. In this case, your etch of 25 drops to an ounce of gum is too strong, and there will be an instantaneous reaction. The carbonic gas will be released so quickly that the effervescence will spring into being as soon as the etch touches the stone and it will be milk-white in color. This indicates that your etch is much too strong and should not be used, as it will melt away the grain that holds the light tones, and nothing can bring back the tone that will have been destroyed if this etch is used on the drawing. Do not use this etch, or any etch of the same strength, on a crayon drawing.

Carefully wash the etch from the margin with a sponge and water, taking care not to get any of it on the drawing. Throw away the etch remaining in the dish. Clean the sponge. Wash the dish and the acid brush with water. Then mix another etch, measuring 1

ounce of gum solution in the graduate and pour it into the dish. Take acid from the acid bottle with the pipette, and this time, knowing that 25 drops is much too strong, suppose we try less than half that amount of acid and add only 10 drops to the gum solution. Mix the acid carefully with the gum solution, dip the end of the brush in the etch, and apply it to a part of the margin of the stone that the first etch did not touch.

Observe carefully the reaction of this etch. It will not spring into milk-white effervescence at once. The reaction will be a great deal slower. It will take between thirty and forty seconds for the first carbon gas bubbles to appear, and a full white effervescence will not appear until at least four minutes have passed. This indicates that the etch is safe to use. We know that, because of the delayed reaction, it attacks the stone gently and not violently as the first etch did, and because the reaction is slow it can be successfully controlled.

This control of the etch is obtained by the manipulation of the acid brush when the etch is applied to the drawing on the stone. This new etch is not strong but, weak as it is, it will do the work of etching if it is left on the drawing long enough. If the etch is not left on the stone long enough, it may not etch the drawing sufficiently. This will cause the stone to overload with ink when printing, and produce impressions that are too dark, and not true to the drawing. If the etch is left on the stone too long, it will melt the grain and produce the same effect that a strong etch does. These troubles can be avoided by a careful manipulation of the acid

brush and the realization that the light tones and lines in the drawing do not need so long or so strong an etching as the dark tones and lines.

Dip your acid brush in the etch, get a full load on the brush, and press it against the side of the dish in order to avoid dripping. With a slow, easy one-stroke motion, brush the etch across the bottom of the drawing. Do not scrub the etch onto the stone. As soon as you have completed your first stroke across the stone, dip your brush in the dish of etch and make another slow, easy stroke across the drawing, blending the edges of the strokes. Do this again and again until the entire surface of the stone, including the margins, is covered. Watch the stone carefully for effervescent bubbles; as soon as they appear (they will take a little longer on the drawing than on the margins), dip your brush into fresh etch, and brush all over the stone with a back-and-forth motion. This action will break up the effervescent bubbles and move the acid parts of the etch to other spots, allowing the gum to get at the spots attacked by the acid, and so prepare the stone. By this action of manipulation, you are constantly adding fresh etch to the stone and breaking the action of the acid so that it will not be continuous for too long a time in one spot. As the acid is not too strong to begin with, and as you are preventing a steady corrosive action by brushing with the acid brush, the chemical changes on the stone will take place slowly but surely. If some sections of the drawing are darker than others, you may allow the etch to stay on these places for sixty seconds before brushing it away.

Brush fresh etch on the dark section and leave it there for another sixty seconds. In the meantime, keep brushing the old etch mixed with fresh etch over the lighter portions.

Always bear in mind that you must keep brushing the etch away from the light parts of the drawing to the darker parts. This is necessary because the darker parts need a longer etch than the lighter ones, and we are of necessity etching these different tones on the same stone with the same etch.

Keep the etch moving on the stone for four minutes. During the last minute move the etch over all parts of the drawing, light as well as dark. As you do this you will notice that the acid brush will stir up the effervescence into a milk-white foam. This is caused not only by the carbon bubbles but also by air that the brush has picked up by reason of its motion. As soon as the four minutes are up, place the acid brush in the etch dish, and quickly take a flat sheet of newspaper and blot the etch from the stone. Do not rub with the newspaper. Lay it gently on the stone and press it down with your hands. As soon as it is wet, peel it off and throw it away.

There will still be wet etch left on the stone. Take a large clean rag, making certain that there are no pins or buttons in it, make a compact wad about 9 inches in diameter, and rub the etch down on the stone until it is quite even and almost dry. Then fan the etch until it is dry. After the etch is dry, stand the stone on edge and with a wet cloth or sponge wipe away any drops of the etch that may have fallen on the press bed and to

the bottom edges of the stone. Remove the stone from the press, and set it on a chair or table. Wash the press bed with water, and dry it. Then set the stone back on the press. Wash out the acid brush with water. Throw away the leftover etch and wash the etching dish. Wash all the rags you have used so that you may use them again. Wash the sponge, throw away the remaining gum solution, and clean the gum jar.

Before we conclude this discussion of etching, we might well consider a few of the other things you need to know about etching a stone. The basic measurement for gum arabic solution should always be constant when used with nitric acid. One ounce of the gum solution is a good quantity as it is more than enough to cover completely a stone 16 x 20 inches. Using 1 ounce of gum arabic solution as a constant, the mixture with nitric acid can always be correctly measured. In directing you to use 10 drops of nitric acid to 1 ounce of gum solution, we are assuming that you have made your entire drawing with a No. 4 crayon, with light and dark tones and lines. Should you make a drawing with the No. 4 crayon with only dark and black tones, a slightly stronger etch will be needed. In this case, add two to three more drops of nitric acid. If you should make your drawing with a No. 3 crayon, 12 to 14 drops of acid in 1 ounce of gum solution will be required to etch the stone. A drawing made with the No. 2 crayon will usually need from 14 to 16 drops of acid to 1 ounce of gum arabic solution.

These additional amounts of acid are needed because

the softer crayons contain more ingredients that have to be unsaponified than does the harder No. 4, and the heavier the crayon is on the stone the longer it will take to make the change. Four minutes will usually do the job. When you use a stronger acid, keep some pure gum arabic solution near at hand. If the effervescence seems to be reacting too quickly, ¼ ounce of the gum solution poured on the stone will dilute the etch and slow up the action of the acid.

Remember that the etching of a crayon drawing on the stone in no way resembles the etching action in copper-plate etching. The etching solution on stone is used only to obtain a chemical change and not to bite lines. When you have completed etching the stone and dried the etching solution, you can rub your hand over the surface of the stone and feel its smoothness.

One other point about etching the stone may be useful. The lithograph stone is susceptible to weather and temperature conditions. So is nitric acid. In warm weather, the acid will react on the stone more quickly than in cold weather, and the etch of ten drops of acid to an ounce of gum arabic solution may also react more quickly. In cold weather, this same etch may not seem to react at all. Because of these changing conditions, always test your etch on the margin of the stone and observe the reaction. If your etch causes effervescence to start within thirty to forty seconds, it is strong enough. If effervescence does not start within that time, you may add two more drops of acid and test again. If it still does not work, add another drop or two. If the

acid reaction seems too strong, add a quarter of an ounce of gum solution to weaken the etch.

Besides the weather delaying or quickening the reaction of the etch on the stone, the stone itself may have something to do with it. No two stones will have the same reaction to the etch at the same time, as they are all a little different from each other. The difference is usually not great, but because of this difference, your reaction test on the margin will always be a reliable guide to successful etching.

The next step we have to take in the making of a lithograph is to wash out the stone for printing. Before we do this, we have to know something about the press, rollers, paper and other related materials. As the stone is now etched, nothing can harm it, and so we can take a little time to talk about how to use the printing materials.

ETCHING REFERENCES:

The Invention of Lithography, by Alois Senefelder. J. W. Muller translation, pp. 124-126. The Fuchs & Lang Mfg. Co., New York.

"Lithographic Notes," by Albert W. Barker, *Prints* magazine, issue of February, 1937, Vol. VII, No. 3, pp. 139-142.

Lithography for Artists, by Bolton Brown, Chap. VIII, pp. 54-65. The Scammon Lectures for 1929, Art Institute of Chicago. Chicago University Press.

V

The Lithograph Press

MATERIALS NEEDED:

Lithograph hand press, bed size 24 x 36 inches
Battleship linoleum for press bed
¼-in. carpet tacks, hammer, pliers, saw
Machine oil
Scraper wood
Scraper leather
Pressboard tympan
Heavy white porcelain blotters
1 1-lb. can automobile cup grease
1 two-inch paintbrush

In graphic art printing three types of presses are in use. Each press is designed for its own particular kind of printing. The press used for printing wood engravings exerts a downward pressure and presses the printing paper against the raised portions of the inked, engraved block to make the impression. The etching press is operated by causing the copper plate to travel on a bed between steel rollers that exert a rolling two-way pressure which forces the printing paper into the lines of the etching. The print is made by the paper pulling

the ink from the incised lines on the plate. The lithograph press uses a still different kind of pressure. The pressure is obtained by a lever that forces the stone on the press bed against the scraper fixed in the scraper box suspended in the frame of the press. When the bed is moved by means of a crank handle, it is carried over a heavy steel roller. The scraper, resting on a greased tympan covering the stone, forces the printing paper against the printing ink. The ink is scraped from the stone to the paper to make the print.

As only a lithograph press is capable of taking perfect impressions from the lithograph stone and is the one that we use, a detailed description of the press and the way to use it will make things easier when we start to print the stone.

Lithographic hand presses are no longer manufactured. In commercial lithographic printing plants the hand presses are used to make transfer impressions from stone to metal plates that are later printed on a power press. Process methods, involving photographic negatives on glass and offset proofing by power, have made the use of the hand press almost obsolete in industry.

The only presses that can be purchased by the artist are those that have been bought up by lithographic supply houses, and reconditioned for sale. Once in a while you may hear of a printing plant that is trying to dispose of hand presses, and you may be able to get one at a low price, ranging from $15 to $75. Supply houses usually sell hand presses at about $100.

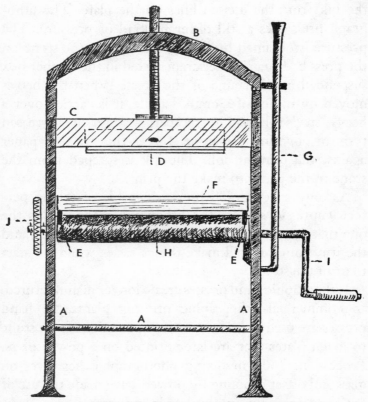

FRONT CROSS SECTION OF LITHOGRAPH PRESS

 A. Leg frame and crossbar.
 B. Head.
 C. Screw and scraper box.
 D. Scraper.
 E. Rollers.
 F. Press bed.
 G. Pressure lever.
 H. Steel roller.
 I. Crank.
 J. Gears.

The press that is best for the artist to use is about 4 feet 2 inches long, and about the same measurements in height at the highest point in the head of the frame. It is about 3 feet 6 inches wide, outside dimensions, and carries a bed of about 24 x 36 inches. A space of approximately 6½ by 9 feet will be ample room for the press and for you to work in. The press weighs about 500 pounds. The construction is quite simple and seldom can get out of working order.

The press is made of cast iron and has a frame consisting of three parts. Two of these parts are the legs which are joined together by crossbars fastened with removable bolts (see (a) in drawing of the press). The other cast-iron part is the head (b) that holds a screw (c) that in turn holds the scraper box. The scraper box in turn holds the scraper (d). On the tops of the frame legs of the press are a series of small rollers (e) that make a track for the bed (f). Pressure is obtained by moving the pressure lever (g) to a position parallel to the bed. This action, by means of a cam, forces the steel roller (h) against the bottom of the bed, thus forcing the bed to raise the stone against the scraper. When pressure is on, the stone is immovable against the scraper. The tympan, which must always cover the stone when printing, is greased to allow the stone to slide under the scraper when the bed is moved by the turning of the crank (I). The gears (J) are opposite the crank and are connected to the crank rod. The gears allow the bed to be moved with a minimum of physical effort. Do not

purchase a press without gears. Ungeared presses are direct in action, and the stone is printed by sheer muscle power that becomes quite arduous during a run of printing. Gears ease the work of operating the press.

The gears of the press must be lubricated. The best lubricant is summer-grade automobile cup grease, which can also be used to grease the tympan. A two-inch paintbrush can be used to advantage in applying the grease to the gears. Do not spare the grease as it will last a long time and ease your work.

The rollers that carry the press bed are best lubricated with machine oil. There are holes in the rollers to receive the oil. A few drops every month or two will keep the bed easily movable. Use an oil that will not gum. Machine oil of this type can be purchased at any hardware store.

Your press bed may have a covering of a rubber blanket or battleship linoleum. If it does not have this covering, it would be well for you to put one on. Battleship linoleum is a good covering and can be obtained at any shop that sells floor coverings. A press bed cover is needed as the bed is made of hardwood contained in an iron frame. These materials have no resilience, will not allow for leeway in pressure, and may cause broken stones. Linoleum or rubber will give this margin of safety when the stone is under pressure. Lay the linoleum or rubber sheet perfectly smooth on the press bed and tack it along the edges. Do not use tacks on the area that may be covered by a stone. If you allow the

heads of the tacks to protrude a little, they can easily be pulled out when the new linoleum stretches. After the linoleum covering has been used for a month or two, it will have stretched as much as it is going to and then can be tacked down permanently. As an alternative you may cement the linoleum on the press bed in the same way that linoleum is cemented on a floor. The cement can be obtained at any floor-covering store.

The scrapers used in the press have to be made. The material can be purchased from lithograph supply houses. Scraper wood is usually boxwood or maple. It comes in strips 36 inches long and 4 inches wide, and the wood has a V-shaped blunt edge. As the scraper must always be wider than the drawing and narrower than the width of the stone, it is best to cut the wood in varying sizes to take care of different-sized drawings. As you are probably using a 12 x 16 stone, your scraper should be 11 inches long. You will also be able to get two 10-inch scrapers and one 5-inch scraper out of the one piece of wood. These sizes are only suggested, your own needs of course determining the sizes that will fit your stones. All scrapers must be covered with leather so that the scraper will slide easily over the greased tympan. The leather also protects the wood from the grease on the tympan.

Scraper leather comes in strips 1 inch wide, and in varying lengths. Forty-four inches of scraper leather are enough to cover the scrapers cut from 36 inches of scraper wood.

To make the scrapers, measure and saw the wood to the desired length. Cut strips of leather 3 inches longer than each length of wood. It is a good idea to soak the leather in water overnight before stretching it over the scrapers. After the leather has been soaked and the scrapers cut to the desired length, tack one end of the leather 1½ inches along one end of the scraper wood so that the rough side of the leather will be against the V-shaped edge of the scraper wood. One carpet tack will hold the leather. Place the scraper in a vise and grasp the untacked end of the leather with a pair of pliers. Pull the leather as tightly as you can across the length of the scraper, and while you are still holding the tension, tack it down about ½ inch in from the other end of the scraper wood. After you have hammered in one tack, you may release the pull on the pliers. Place another tack close to the end of the leather on both sides of the scraper. Two tacks to an end will fasten the leather securely. After the leather is in place, you will notice that it is wider than the ends of the wood. Trim the leather to the wood along the ends of the scraper, making certain that you leave at least ½ inch of the full width of the leather above the point where it makes the turn across the length of the scraper (see drawing). If the leather is untrimmed, the scraper will not fit in the press scraper box. The ½-inch full width is left on to help prevent the leather slipping off the wood. Allow the leather to dry before using. When the leather is dry, it will tighten and fit the shape of the wood.

The tympan is a sheet of thin pressboard, dark red in color, of several plies of paperboard. They can be purchased from a lithograph supply house. The sheets

WOODEN PRESS SCRAPER

1. Scraper without leather covering (cross section).
2. Scraper with leather covering (cross section).

are about 32 x 60 inches, and one sheet can be cut in half. These two halves will make adequate sizes that will completely cover both the stone and the backing material. Before using a tympan, bend one end 1½ inches so that it forms a right angle down from the main body.

When you are printing, this bent end will fit over the end of the stone nearest to the scraper and will prevent the tympan from slipping when pressure is applied. After you have done this, bore a small hole in the tympan ½ inch from the opposite end. This hole will allow you to hang the tympan on a nail when not in use.

After you have done these two things, the next step in preparing the tympan involves greasing it so that the scraper will slip over it to make an impression from the stone. If the tympan is not greased, no amount of effort on your part will move the scraper over it. A good lubricant to use is the same automobile cup grease used on the press gears. It can be purchased at any garage or service station. The 2-inch paintbrush makes a fine tool with which to apply cup grease to the tympan. Cover the top of the tympan with an even spreading of grease. A little rubbed on the bottom of the scraper leather will help to work both of them in quickly. If the operation of running the press seems to be a little difficult, after it has been operating smoothly, a fresh coating of cup grease on the tympan will solve the difficulty. You may, if you like, use other lubricants than cup grease. Albany grease, usually employed in lubricating elevator shafts, is a good tympan lubricant. It is stiffer than cup grease and more expensive. Mutton tallow and almost any other stiff lubricating substance can be satisfactorily utilized.

Backing material that is placed over the printing paper on the stone and under the tympan acts as a resilient buffer between the stone and the scraper. It

allows the pressure smoothly to press the paper against the stone and avoids all danger of smudging the print while it is being printed. Several sheets of clean unprinted newsprint make a good backing. Care must be taken to avoid sheets that are wrinkled because the wrinkles will be transferred to the printing paper and will show on the print. They may also appear on the tympan and make it worthless.

A heavyweight porcelain blotter, about 26 x 32 inches makes a fine backing material. Blotters of this kind can be obtained from a paper supply house. You will need a quantity of them as they are extremely useful in damping the printing paper and in drying out the completed prints. A blotter, as will the newsprint, will last as backing for many impressions. Sometimes one will last for an edition of 25 prints or more. If blotter or newsprint backing gets wet or creased during printing, discard it.

Remember that all backing materials must present a smooth surface to the printing paper, and that the tympan must present a smooth back to the backing. If your scraper should be too wide for the stone, it will press the tympan against the edges, creasing it and the backing. Should this happen all will be well if you carefully line up the creases in the backing and the tympan. (This is dangerous for an amateur to attempt.) Stones that are not grained perfectly level will cause backing and tympan to wrinkle. The only way to remedy this defect is to use a thicker mass of backing or a makeready. (See Chapter X, page 121.)

Always print with a scraper that is narrower than the stone but wider than the drawing. Keep the tympan well greased and the backing smooth, and you should have no trouble in controlling this part of the process of printing.

VI

The Lithograph Roller

MATERIALS NEEDED:

 1 14-inch buffed hand roller
 2 leather hand grips
 2 leather protectors
 1 old lithograph stone 16 x 20 inches
 1 3-inch paint scraper (wallpaper scraper)
 2 8-inch spatulas or blunt-edge silver table knives
 1 pint each of Nos. oo, 3, and 7 lithograph varnish
 1 1-pound can of lithograph black crayon ink
 Rags
 2 blocks of wood
 Shop apron
 Turpentine
 Newspaper
 Printing ink

As we have the scraper, tympan, and backing material ready, our next problem is to get the roller in shape so that we can print with it. When a roller is purchased from a lithograph supply house it is not ready to use. It has first to be prepared with varnish so that the ink taken from the ink slab will be discharged from the

roller to the chemical printing spots on the stone evenly and with dependability. If a roller is not prepared for this job before it is used, it will absorb the ink and fail to function properly. A new grained-leather roller must be varnished before it can be used. The same varnishing treatment is necessary for an old roller that has not been used for a long time if it was not properly treated before being laid aside for future use.

The roller has a hardwood core, usually maple. This core is about 3½ inches in diameter, perfectly round, with two 4-inch handles. It is covered with a sleeve of heavy felt especially made for use on a roller. A covering of finely tanned, soft, buffed calfskin leather is sewed over the flannel. Buffing is done by the roller manufacturer to make the leather porous so that the roller will not only carry ink, but also will act as a reservoir to help absorb excess water when printing. The handles are a permanent part of the core of the roller. The leather is light tan in color and has a soft velvety texture.

The first step in preparing the roller for printing is to place on a table an old lithograph stone or a thin slab of marble or a sheet of plate glass about 16 x 20 inches in size. Anyone of these may be used as an ink slab on which to ink the roller. Next, get two pieces of 2 x 4 x 4-inch wood, set them on the ink slab, and suspend the roller between the blocks with the handles resting on the blocks so that no part of the leather touches the ink slab.

Open a can of No. oo lithograph varnish and pour

about a tablespoonful on the leather roller. Set the can down where it will not be knocked over, and rub the varnish into the leather of the roller with your fingers. The leather will drink in the varnish and only a small portion will have been covered. Pour more varnish on the leather and rub it in until every spot on the leather has received as much varnish as it will take. At this point, the leather will appear to be wet all over. Put the cover on the can of varnish and forget about the roller for an hour or two.

When you return, you will see that some of the varnish has dripped onto the slab and that parts of the leather will appear to have dried out. Repeat the process of pouring and rubbing in varnish, and give the roller a half turn. Allow another two hours to pass, and then repeat the process of varnishing. Turn the roller each time you apply varnish. You will find that the leather will drink in quite a lot of varnish. Varnish the roller about four times during the day and then allow it to stand on the blocks overnight. In the morning, parts of the leather will appear dry, and the varnishing process will have to be repeated. Continue varnishing at lengthening intervals until, after a period of about six hours without varnishing, the roller does not dry out. This will be indicated by the increasing amount of surplus varnish that will have dripped onto the slab, and the uniform wetness of the roller. About half to three-quarters of the varnish will have been used from the can.

When this point has been reached, scrape the excess varnish from the slab with a 3-inch paint or wall scraper, and throw the used varnish away. Then open the can of No. 7 varnish and dip out some with a table knife. Spread the varnish across the ink slab about two inches from the edge. Take the blocks from under the roller and set the roller on the ink slab. Slip the hand protectors over the handles of the roller, one to a handle, and press them against the ends. The protectors are made of leather, shaped like a doughnut. They are smaller in diameter than the roller, and protect your hands from the rough, corded roller ends.

Next, take up the two leather hand grips, which are two pieces of leather about 4 inches square, and bend them around the handles. After a few hours' rolling, the grips will fit the shape of your hand and that of the roller handles. You can predetermine the shape of the grips by soaking them in water and then tying them around the roller handles. If you do this, tie them loosely, as you will want to be able to manipulate them easily when rolling on the stone. Put on a shop apron to protect your clothes. The apron can be purchased at any workman's supply store.

Grasp the roller tightly with the back of the thumbs toward your body, and the fingers away. Roll the roller into the varnish and keep rolling until the varnish is completely distributed all over the roller. You will notice that the No. 7 varnish will make a loud swishing sound, and that it is very tacky. The reason for using

this stiff varnish is twofold. In the first place, it pulls all the excess No. oo varnish from the leather; second, it loosens bits of fuzz from the leather and deposits it on the slab.

Add another dab of varnish to the slab and keep rolling for about twenty minutes. Then stand the roller with one of the handles against one end of the slab and the other resting against your stomach, just above your belt. Take one of the table knives or a spatula and hold it with the handle in your right hand. Grasp the other end with your left hand and place the edge parallel to the upper side of the roller. Tilt the knife until it rests on the roller at a slight angle. Scrape the varnish with a slow, steady downward thrust. Be careful not to cut the leather. Turn the roller slightly so that the knife will scrape a fresh layer of varnish from the roller. Then turn the roller end for end and work until you have gone over the entire surface.

Do this until you have scraped off as much of the varnish as you can. Then set the roller on the blocks on the press bed and scrape all the varnish and fuzz from the slab with the paint scraper. Then wash the slab with turpentine. Throw away the scraped-off varnish, and then place more fresh varnish on the slab. Take up the roller and roll it in the varnish as before. If you get tired of rolling, set the roller on the blocks until you are ready to continue. After each session of rolling, scrape the roller and the slab. Rolling in the varnish should be kept up at intervals of one hour for about twenty-four

hours, or until the stiff varnish has pulled all the fuzz from the roller. About fifteen to twenty sessions of rolling should be sufficient. After you are satisfied that this has been done, scrape the roller and the slab. Clean the slab with turpentine and newspapers. When the slab is completely cleaned of the varnish, clean the knives with turpentine.

You are now ready to ink the roller, but it is not yet ready for printing. Take ink from the can with one of the knives. You will notice that the ink is quite stiff. A dab of ink about the size of a walnut will be enough to start with. Do not thin the ink; use it as it comes from the can. As it is in one lump, it has to be worked before spreading it on the roller. Take the paint scraper and work the ink with it on a corner of the slab until the ink is smooth, shiny and without lumps. This will take between five and ten minutes. When the ink is smooth, place the roller on the slab. Take up about ½ teaspoon of ink on one of the knives, and place it on the roller. Then spread it with the edge of the knife across the length of the roller. Grasp the roller as before and roll on the slab until the ink is evenly distributed.

You will notice that this amount of ink does not completely cover the roller. Add more ink, either by adding it to the roller or by spreading it on the ink slab. Continue rolling for about twenty minutes. Some fuzz may still be coming off the roller. At any event, scrape the roller and clean the ink slab as before, re-ink, and con-

tinue to roll and change ink frequently. When the surface of the roller has a smooth deep velvety appearance, it will be ready for use. The roller should be rolled and scraped for about twelve hours at intervals of one hour. If you are not ready to use the roller at once, scrape it down. Never allow the roller to rest for any length of time on the leather except, of course, while you are printing. It would be a good thing to bore a hole in the top of the table that holds the ink slab. When you have finished printing, place one of the handles in the hole. This arrangement will hold the roller upright and keep the leather free from contact with any surface. Always scrape the ink from the roller after you have finished printing. Printing ink contains oils and varnish and will stretch the leather if not scraped off.

Your hands will probably be tender when you begin using the roller, and the rubbing of the hand grips may raise painful blisters between your thumbs and forefingers. A piece of adhesive tape will protect your skin. The best way to build up resistance to roller blisters is to roll for a little while at a time, allowing your skin to toughen gradually to meet this new strain.

When you roll the roller either on the ink slab or on the stone, never grasp it tightly. Use your fingers to exert a downward or sideward pressure when you want it. At other times merely guide the roller. After a stroke across the ink slab or stone, turn the roller a little with a backward motion of your wrist. After a while you will be able to do this without stopping the rolling

action. This turning causes new parts of the roller to come in contact with the ink slab and pick up fresh ink. While you are rolling the stone, the printing spots will be continually taking fresh ink from the roller. If the roller is not turned, only about half of it will take and deposit ink, and you will work much harder for the results that can be obtained with a full load of ink.

Later on, after you have been printing, there may come a time when you will not be using the roller every day. If only a day or two elapses between printings, you can keep the roller in good condition by wrapping it in wax paper after scraping. A double wrapping of wax paper will keep the roller for as long as two or three weeks. When you are ready to print again, scrape the roller to take off any ink that you may have missed when you set it aside, and then ink it. The roller will get into condition more quickly if you ink it and then scrape it down once or twice before you ink it for printing.

If you want to set the roller aside for a longer period —for one to six months, or even a year—the wax paper will not keep the leather soft. You will have to coat the roller with a nondrying substance. Proceed as follows: First scrape the roller until all the ink that you can remove is taken off. Then coat the roller with an even coating, about ⅛ inch thick, of mutton tallow, by rubbing it on with your fingers. Mutton tallow can be purchased in a can at any hardware or plumber's supply store. After the mutton tallow is on the roller, wrap the roller in wax paper and hang it up by the handles, mak-

ing sure that it does not touch a wall or any other surface. If you cannot get mutton tallow, white vaseline will do as well. The same process of cleaning must be used to clean vaseline from the roller as you use to clean off the mutton tallow.

When you are ready to print again, remove the wax paper, and then scrape off as much of the mutton tallow as you can with one of the scraper knives. After you have done this, get an old pail and wash the rest of the mutton tallow from the roller with turpentine or kerosene. This will be a messy job, but rubber gloves will keep your hands clean and make the work easier. When you have removed all traces of the mutton tallow, you will notice that you have also removed all the old ink from the roller.

Hang the roller by its handles until the turpentine or kerosene has evaporated, and then ink it and roll it on the ink slab. After you have rolled it for about half an hour, adding more ink as you roll, scrape it down, re-ink and repeat the rolling. After you have inked and scraped the roller several times, re-ink and roll on the ink slab until the roller has its usual deep velvety appearance. Then it is ready to use.

You can save yourself this cleaning job if, even though you are not going to print, you ink, roll, and scrape the roller every week or two, and keep it wrapped in wax paper between rollings. It is imperative that you keep the roller in good condition. The best rule to follow in keeping a roller in good condition is this: Use it daily if you can. The more you work a

roller the better it will respond. When you do not use it often, protect the leather from the air to prevent hardening. If you allow the roller leather to dry out, you will have to treat it just as you did when you first broke the roller in for printing.

VII

Preparing Paper for Printing

MATERIALS NEEDED:

Printing paper
White blotters size 19 x 24 inches
Damp press
Sponge
Oilcloth

You are now almost ready to begin printing your lithograph. Before you start to work, the printing paper must be damped. This is necessary because dry paper cannot be pressed into a complete contact with the printing surface of the stone. When the paper is dry, the fibers are stiff and resist pressure. When the paper is damp, the fibers yield to pressure.

The paper must not be wet, for much moisture will prevent the ink from adhering in full strength. This will produce an impression with weak tones. If the paper does not have enough moisture, your impression will be as weak in tonal strength as an impression on paper that is too wet.

The problem is to arrive at the proper amount of

dampness that the printing paper should have. That problem can be overcome by the methods of damping the paper. As printing papers are different in weight, filler, and capacity for water absorption, it would be wise to discuss two very different kinds of printing papers that have proved themselves excellent for printing creative lithographs.

The first paper that can be highly recommended is known as Rives B.F.K. It is a handmade rag paper of French import that can be obtained at Andrews-Nelson-Whitehead, Inc., 7 Laight Street, New York City. Rives paper comes in two weights. Always get the heavy one. The lightweight paper is good, but less reliable than the heavy. The heavyweight paper has an excellent balance of expansion and contraction between the paper fibers and the filler. This prevents wrinkling and uncontrollable stretching when the paper is damp. If this paper is unobtainable, Andrews-Nelson-Whitehead can supply you with substitutes.

A homemade paper press can be made for damping the paper. If you intend to do a great deal of printing and need to have damp paper on hand often, you might like to construct a damp press. This damp press will hold and evenly damp enough paper for about a hundred prints. It is simply constructed. The outside dimensions of the damp press should be about 2 inches larger all around than the size of the blotters, say about 24 x 34 inches. The bottom of the damp press may be made of planed and sandpapered tongue-and-groove boards

screwed in place by two strips of 1 x 2-inch board. Fasten the strips across the width of boards about 2 inches from each end. Be careful that the screws do not extend completely through the boards that form the

PAPER DAMP PRESS
A. Top.
B. Bottom.

bottom. After the bottom is ready, take four more strips of 1 x 2-inch board, and nail them to the upper part of the bottom piece so that the 2-inch width will constitute the sides. This combination will make a shallow box.

Next construct a top for the damp press the same way the bottom piece was made but with two differences in

construction. First, make certain that the dimensions for the top will allow it to fit freely into the box and rest on the bottom. Make the top about ¾ inch shorter both ways than the box. Second, fasten the cross strips of 1 x 2-inch board closer together, about 6 inches from the ends of the top boards, so that you can lift it off easily. Make certain that the cross strips do not interfere with the free passage of the top into the box. After both top and bottom have been made, line the underneath surface of the top with oilcloth, oily side down. Then line the box part with oilcloth, oily side up, to cover both bottom and sides. About 2 yards of oilcloth will be necessary. This oilcloth will keep moisture from evaporating and enable you to keep printing paper in condition during long printing periods.

When you are ready to damp the paper, take a clean blotter and wet it. You can do this under a tap or by pressing water into it with a sponge. If you wet the blotter under a tap, allow the excess water to drain off before you place it on the oilcloth in the bottom of the damp press. If you should use a sponge, do not scrub the water onto the blotter. Place the sponge on the blotter and press the water from the sponge with the heel of your hand. Then pick up the sponge, wet it, and press the water to the blotter. Keep on doing this until the blotter is evenly wet. Scrubbing with the sponge will loosen bits of blotter that will not only be difficult to free from the sponge, but will also adhere to the printing paper and cause difficulty when printing, by sticking to the stone and getting into the ink.

After you have placed the wet blotter in the damp press, you are ready to put in the printing paper. Rives paper comes in large sheets, and if your drawing is not larger than 10 x 14 inches, a quarter sheet of paper will take the impression with a small margin to spare. If your drawing is larger, a half sheet of the paper will be needed.

Always damp more paper than you will need for a complete edition of prints; some of the first proofs will be too light to be usable. If you want an edition of twenty prints, damp thirty sheets of paper. It is always a better policy to damp extra sheets than to cut corners too closely and find that you have run out of damp paper with the edition only partly completed. If that happens, you can place undamped paper in the damp press, one or two sheets at a time, and use them as soon as the stone is inked for an impression. Good prints, obtained by this method of damping, are generally a matter of chance. Sometimes you get good results and sometimes you do not. Also, it is usually necessary to increase the press pressure to make up for the lack of complete dampness in the fibers of the paper.

Let us suppose that you want to damp forty sheets of paper that have been cut to the quarter-sheet size. Divide the paper into two stacks of twenty sheets each and place the stacks side by side on the wet blotter in the damp press. Then wet another blotter and place it over the paper. After this is done, put the top of the damp press over the blotter. As the top is smaller than the sides, it will press on the blotter and paper and force

an even amount of moisture through the two stacks. This method of damping will take overnight. Place the paper in the press in the evening and it will be ready for use next morning. You can damp as little as ten sheets of paper in this way. If you damp only ten sheets, keep them all in one stack.

If paper is left for too long a time in the damp press, mildew will set in and ruin both paper and blotters. Paper should not remain in the damp press more than two days, if the weather is warm. About four days is the limit if the weather is cool. If you had planned to keep the paper and blotters in the press for a longer time, it would be wise to use a few drops of eugenol or carbolic acid in the blotter-damping water. Either one will destroy the mildew and keep it from forming. It is not necessary to use a preservative directly on the paper.

It is good practice to wet the edges of the blotters to keep the edges of the paper from drying out and so prevent buckling when you leave the paper in the damp press for more than one day. It is also good policy to wet the blotters each day to ensure a continuous supply of moisture in the damp press. This depends on how much paper remains in the damp press after you have completed your first day's printing.

If there are still some sheets of paper unused when you have finished printing, take them from the damp press and dry them between dry blotters. They can of course be used again. If you are not planning to print for a week or two, take the blotters from the damp

press and dry them. They, too, can be used again. You might also dry out the damp press to prevent mildew discoloration on the oilcloth.

You may want to damp forty or more half sheets of paper in the damp press. Divide the paper into two stacks. Place one stack on the wet blotter in the damp press. Then place another wet blotter over the paper. Next place the other stack of paper on the blotter and cover with a third wet blotter. Put on the top of the damp press. The paper will be ready for printing the next morning; or, if you wet it down in the morning, it will be ready in the evening. If you damp more than forty half sheets of paper, it is a good rule to place a wet blotter on each twenty-five sheets to ensure the even damping of all the paper.

The second paper that is liked by artists for its fine printing qualities is known as Chinese India paper which can be obtained from any lithograph supply house. This paper is made by hand in China, is light gray in color, and is very thin. It pulls a beautiful impression but, because of its thinness and color, is not quite so popular with artists as the Rives paper. Chinese India paper pulls to pieces after an impression is made if it is too wet. It has a slightly sticky surface on one side that must not come in contact with the stone. If it does, the paper will pull apart and the impression will be spoiled. After you take the paper from the damp press, touch it to your lower lip. If the surface is tacky, place the other surface down on the stone. To dampen Chinese India

paper, have your damp press ready for use with about ten sheets of Rives paper evenly damped between the blotters. Cut the Chinese paper to the size you require and slip one sheet of it between two sheets of the damp Rives paper. Do not allow the Chinese India paper to remain between the Rives paper for more than five minutes or it will absorb too much moisture. Slip new sheets of the Chinese India paper between the Rives paper as your printing progresses.

If you do not care to construct a damp press, you may follow the same principles by laying out a sheet of oilcloth about two yards square on a flat, even surface. Place a damp blotter on the oilcloth and stack the paper on the blotter. Cover the paper with another blotter and then enclose both paper and blotters with the oilcloth. Make certain that both sections of oilcloth are smooth, and free of wrinkles or creases, as they will make an imprint on the paper. Then place a flat sheet of zinc, iron, copper, or plate glass on top of the oilcloth. An old drawing board may be used. The weight of the metal or glass will press the moisture through the paper. This method takes about the same time for damping as does the damp press.

If you should want to damp and use the paper for printing quickly, lightly wet each sheet of paper on both sides with a clean sponge, using the same method of wetting the paper as you use to wet a blotter with the sponge, except that you must not wet the paper through and through. Use a sponge that is wet but not

saturated. Stack the paper in oilcloth between damp blotters, use a metal sheet on top of the oilcloth and weight the stack with a lithograph stone. Prepare for printing. When you are ready to use the paper, remove the weight, and take a sheet of paper from the stack. Always re-cover the stack with the oilcloth, until you are ready for another sheet. This holds good for the damp press as well as the oilcloth-stack method of damping.

There is a way to test paper for dampness before laying it on the stone for printing. Pick up a sheet between thumb and forefinger and shake it gently. If it crackles stiffly, it is too dry and should go back for more damping. If it does not crackle at all, it probably is too wet and should be exposed to the air for a few minutes. You can do this by laying the sheet on a dry blotter. If the paper has a very slight crackle, it is right for use.

Never soak the paper with water. All that is needed is a slight even dampness to induce flexibility.

While the Rives B.F.K. and the Chinese India papers are fine for printing creative lithographs, other papers can, of course, be used. Any handmade or machine-made wove paper will take good impressions from the stone and you can get printing samples from manufacturers or paper supply houses by writing and asking for them.

Lithographs can be printed on Manila wrapping paper, typewriting paper, and in fact on almost any kind of paper if you are not concerned with getting a fine print that you intend to exhibit. You can even pull

impressions on cotton, linen, flannel, or silk, without damping the cloth.

When you use a heavyweight paper, damp it in the manner suggested for the Rives paper. When you use lightweight paper, damp it according to the method given for the Chinese India paper.

You may want to experiment with printing papers to find the ones that will give you the most pleasure in handling. Try as many as you can until you find those most suitable for fulfilling your own creative intentions.

VIII

Printing the Lithograph

MATERIALS NEEDED:

Table
Ink slab
Roller
Printing ink
Turpentine
Water
2 water pans
Sheep's-wool sponge
Snake slips
Gum arabic solution
Rags
Tympan
Square

Until now you have been getting your materials ready for printing. The stone has been etched, and the roller has been broken in. Before you take up the next step in the process, it would be well if you arrange all the printing materials so that they are convenient to your hand. If you plan to print in the morning, it is a good idea to set out the materials the previous evening.

75

If you want to begin printing without a period of waiting between the preparation of materials and actual work at the press, you will have to get the materials ready before you ink the stone. Whatever your plan of arrangement, the following will assure you a good working procedure.

The first thing to do in getting ready to print is to mix a fresh gum arabic solution. After that, damp your printing paper. If you do these two things the evening before you intend to print they will be ready to use in the morning. You may, of course, make a gum arabic solution and then damp the paper with water just before you print. In that case, always prepare the gum solution and the paper before doing anything else, as they take longest to get ready. Next, take ink from the can and work it on the ink slab until it is ready to use. Then scrape the roller, apply ink to it, and distribute the ink by rolling the roller on the ink slab. Keep rolling until the roller has a dull velvety appearance. When the roller is ready, place it in the holder.

While waiting for the gum arabic to dissolve and the paper to damp we might consider the arrangement of some of the other materials that you will soon be using. The press is, of course, one of the most important. Be sure that it is well greased and oiled, and that there is sufficient space for you to turn the crank handle without skinning your knuckles on an obstruction. Be sure that the press bed has a good light over it placed in a position that will not cause your shadow to fall on the stone when you are working. This is important because

a poor light or a shadow on the stone will interfere with your vision and may lead you to overink the design.

The ink slab should be placed on a strong table that stands solidly on the floor. The light on the ink slab should be good enough to allow you to see at a glance the condition of ink and roller. If your inking table is large enough, that is a good place to keep two water pans, a sheep's-wool sponge, a piece of snake slip, the paint scraper, and the two ink knives. The water pans should be about 8 inches across the top and 3 or 4 inches deep. One of them, nearest to you and the press bed, should always contain clean cool water. The other is to be used as a slop pan to hold dirty water that you will squeeze from the sponge from time to time. The water pans can be purchased at a 5- and 10-cent store and can be enamel or aluminum or anything you happen to have.

The sheep's-wool sponge should be purchased from a lithograph supply house. Sponges vary a great deal in texture, and if you buy it locally you may get one that is too coarse to lay down an even film of water on the stone during printing. Before you use the sponge on the stone, wash it thoroughly with warm water. Brine, and sometimes bits of seaweed and dirt that may be present should be eliminated. As you squeeze the wet sponge you may feel bits of broken shell. Remove as much of the shell as you can because the sharp pieces will scratch the stone.

The snake slip is an artificial pumice that comes in

flat or round sticks. It is used to make corrections on the stone and can be obtained at any lithograph supply house. Its name is derived from a natural stone found in Scotland, called snakestone. This natural snakestone is cut into thin slivers called "slips." Hence the name, "snake slip." The manufactured snake slip performs the same function as the natural snakestone slips. A natural snakestone is hard, can be sharpened, and is useful in correcting errors on the design. It is known as "water-of-Ayr stone," and can be purchased at a lithograph supply house.

One of the ink knives should be used to take ink from the can, and to apply worked ink to the roller. The other knife should be reserved to scrape old ink from the roller.

The ink table with its equipment of ink slab, roller, snake slip, ink knives, water pans, and sponge should not be more than a step from the press bed. The best arrangement is to have the ink table at right angles to the press with one of the short sides of the table forming an extension to the press frame. The length of the table with the press will form a working space in which you will be able to print with minimum effort.

The tympan should be greased and ready for use and the backing should be in a convenient location near the press. Turpentine should be kept ready for use at any moment. A good way is to have it in a pint bottle that has a cork. Take a sharp knife, make a small notch the whole length of the cork and jam it tightly in the neck of the bottle of turpentine. When you need to use tur-

pentine, you can sprinkle a few drops at a time through the notch in the cork without uncorking the bottle. This will prevent your flooding the stone with turpentine. You may use ordinary turpentine that can be purchased at any hardware store. Get the kind that comes in cans. Loose turpentine may contain traces of linseed oil, and should not be used. Rectified turpentine can be used but, since it is not any better than ordinary turpentine for washing out the stone, there is no need for it. Other solvents that can be used are naphtha and gasoline; as they are highly inflammable and work no better than turpentine, it is best not to use them.

Several large clean rags about 24 inches square will be needed and should be kept in a clean and convenient place near the press. You will need them in a hurry, so have them where you can reach them quickly.

Before we get down to work, let us theorize for a moment on what we are going to do. The conditions are these: You have grained a lithograph stone composed of natural limestone. On this stone is a drawing that has been made of a soluble soap, or, if you like, grease crayon. By means of the etching process you have sealed the undrawn parts of the stone against grease but have kept them receptive to water, and at the same time you have unsaponified the grease content of the crayon and made the sections that you have drawn an integral part of the stone's surface. These drawn parts retain their attraction for grease and cannot retain water. The entire stone still has its coating of

dried gum arabic solution and acid which, when dry, is chemically inactive. What to do next?

We want to remove the old etch that has served its purpose. We also want to remove the lampblack and residue of the crayon from the design, and expose the greasy chemical printing spots that are the result of the etch's action on the original crayon drawing and the stone's surface. This is necessary so that the ink on the roller may have full and complete contact with every printing spot on the stone. In order to prevent the ink on the roller from covering the entire stone and making it solid black, it is vital always to present a thin film of water to act as a buffer between the ink on the roller and the design on the stone. The parts of the stone that have not been drawn on will retain water and thus repel the ink, as grease and water will not mix. The printing spots will repel the water and attract ink from the roller. This is the basic fact on which lithography in all its branches has been built. If the stone has no protective film of water covering its surface when the roller is applied to it, the ink will take all over by simple mechanical adhesion.

After the design on the stone has been inked, a sheet of printing paper will be placed over the design. Then backing will be laid down over the paper, and over that the tympan. The stone will be run through the press, and, after tympan and backing have been removed, the print will be lifted from the stone. Each time the design is rolled with ink, a protective film of water must be laid over the stone. When the stone is re-inked, an-

other sheet of paper will be laid over the design, then backing, and tympan. The stone will be run through the press and another print will be lifted from the stone. This will go on until as many prints as are wanted have been taken. The stone can then be set aside for printing at another time, or it can be regrained until it is clean and free of grease and scratches. Then the cycle of drawing, etching, and printing is ready to begin again.

This is what you are going to do, and here is how to do it: First, place the stone on the press bed. Then take up a scraper and hold it over the stone to see that it is wider than the drawing but narrower than the stone. If it is, insert it in the scraper box and turn the set screw until the scraper is held firm. Then strain the gum solution into the graduate through the cheesecloth. Make two pads from the 24-inch rags, and set them aside for the moment. One of the rag pads is to be exclusively used for turpentine, and the other for gum. Do not get them mixed. Never use a pad with turpentine on it to smooth down wet gum on the stone as the turpentine will dissolve either ink or crayon under the gum. Use a turpentine pad only when you are wiping turpentine on the stone, and use the gum pad only when you are rubbing down a gum arabic solution or an etch. Different colored or textured rags may be used to distinguish them.

To remove the old etch from the stone, take your sponge and wet it thoroughly. Then squeeze it into the slop pan until most of the water is gone. Do not have the sponge too wet, as the water will overflow onto the

press bed. Have it just wet enough to hold about a quarter of a cup of water. Wet the stone with the sponge, and wash off all the old etch. You will be able to see it come off as the sponge rubs over the stone. After the stone is cleaned of the old etch, take up the excess water with the sponge by wiping the stone.

Then pour ¼ ounce of the fresh gum arabic solution on the margins of the stone. Take the clean pad that you have set aside for gum use, and smooth the gum all over the damp stone. Refold the pad to make a dry surface and briskly rub the stone until it is almost dry. The gum should be lying on the stone in a thin even coat. If this gum coating is thick and rough, the next step of washing out the crayon with turpentine will be difficult, as the turpentine will not be able to reach all the crayon through the heavy coating of gum. If you think the gum coating is not smooth enough, wash it off immediately with clean water and the sponge, and then recoat the stone with a fresh application of gum arabic solution. When the gum is smooth, complete the drying by fanning. You can tell when the stone is dry by the absence of wet areas and also by lightly rubbing your fingers over the surface. If the gum is still damp, it will be slightly tacky to your touch.

Washing the stone with water and applying a fresh gum arabic solution serves several purposes. It removes the etch, which more or less completely covers the crayon. A washout with turpentine usually is uneven when applied over the etch; therefore, to prevent difficulties in the washing-out process, the etch is removed.

The new gum arabic solution, briskly rubbed down on the stone, exposes the tops of the grain of the stone and with it the crayon. This allows the turpentine to dissolve the residue of crayon and lampblack easily and evenly. At the same time the greasy parts of the stone are kept from spreading by the gum arabic coating, and the undrawn parts are protected from harmful contact with the turpentine and dissolved crayon.

When the gum arabic solution is dry, set the gum pad where no turpentine can get on it. Then take the bottle of turpentine and sprinkle about ⅛ teaspoon of turpentine all over the stone. Pick up the pad which you have set aside for use with turpentine and briskly rub the turpentine all over the stone. You will see all the crayon dissolve and combine with the turpentine. Turn the pad to get a dry surface and rub the turpentine until it has almost dried. Rub it over the stone as smoothly as possible, but do not keep rubbing until it is completely dry. As soon as the turpentine shows signs of drying rapidly, fan it.

When you are certain that the turpentine has dried—you can tell by rubbing the surface with your fingers—wet the sponge with water and wash the turpentine and dried gum from the stone. Your sponge will get full of dirty turpentine and gum. Dip the sponge in clean water and squeeze as much of the turpentine as you can into the slop pan. Then rinse the sponge in clean water and squeeze it as dry as possible. After you have done this, sponge the stone and remove all traces of the gum and turpentine. From this point until you

have finished printing for the day, the stone must always be kept damp. This is important and must not be neglected. While the stone is damp, wash out the sponge until no trace of turpentine remains. Then wash out the water pans and refill one of them with clean water.

By this time the stone will need redamping. Bear in mind that the ink will go down on the stone evenly and readily if the stone is not too wet. When you damp the stone with the sponge, use broad, sweeping strokes first across the width of the stone and then across the length. If the sponge seems to be too dry, do not wet it and then squeeze it dry. You will usually get too much water in it. A better way is to flick a few drops of water from the water pan, with your fingers, onto the stone and then spread it around with the sponge. After you have a thin, even film of water on the stone, you are ready to roll it with the ink roller.

As you have already worked up the ink on the slab, have spread ink on the roller and distributed it on the ink slab, your roller is ready for use. Before rolling the stone, give the roller a few more passes over the ink slab to ensure an even inking, and if the stone seems to be drying, damp it again. As soon as it is damped, pick up the roller, and, holding it firmly but loosely by the leather grips, roll rapidly over the stone two or three times. This rapid rolling will allow the roller to spread the water on the stone to a very thin even film. After you have done this, decrease the speed of rolling to a slow, steady motion, taking care not to roll the roller over the edges of the stone. If you should roll over the

stone's edges, they will pick up ink and have to be cleaned. Do not pass the roller over the stone more than from six to ten times. The ink will have taken to the stone by then, and further rolling without rerolling the roller on the ink slab will be wasted effort. Another reason for not rolling longer is to avoid the friction of the roller from completely drying the stone of the water film. Never continue rolling until the stone is dry. If you do, you will see that ink has taken in places that have not been drawn. If you take an impression with the stone in this condition, the print will be fuzzy, and black on the parts that have taken ink by mechanical adhesion.

There is a good and quick way to remedy this condition. As soon as you notice that the stone has dried, and that ink has taken hold on the dried-out places, you must quickly damp the stone with water and roll the roller rapidly over it. Be careful not to let the stone dry again. The roller will pick up the unwanted ink and the design will be clear again. As soon as you see that it is clear, stop rolling, redamp the stone, roll the roller on the ink slab and then ink the stone, first with a few quick passes and then with a slower, steady motion. As you roll, you will see the drawn parts of the design slowly take ink. Do not attempt to ink the design to the full strength of the drawing with this first series of rollings. After you have rolled the stone with three different inkings, roll the roller on the ink slab and leave it there.

During the inking on the stone, the roller will some-

times absorb too much water. If it does, you will notice that wet areas appear when you roll the roller on the ink slab. If the roller and the ink slab remain in this state, the roller will not take up fresh ink from the slab. The roller leather will have a slick and shiny appearance. Never ink the stone with a roller in this condition as it will not distribute the ink to the design as well as it might. Always keep rolling the roller on the ink slab until the damp areas disappear and the roller has a dull velvety appearance. Then it will take ink from the ink slab and evenly redistribute on the design. To prevent the roller from taking too much water from the stone, make certain that you have only a thin film of water covering the stone. As soon as the roller is in condition for a quick rerolling, leave it on the ink slab and dry the stone. Never damp the stone after the inking is completed and you are ready to take a proof. This is one exception to the rule of always keeping the stone damp. Before you place the printing paper over the stone, fan until it is dry.

When the stone is dry, quickly place the paper on it, watermark side uppermost. If India paper is being used, place the tacky side up. Place the backing over the paper and then the tympan. Slide the bed of the press forward until the scraper is over the tympan at a point that is on the margin of the stone. When you are sure that the scraper will rest on the margin of the stone and not on the design, pull the pressure lever down as far as it will go. This action will elevate the cam, and the cam will in its turn force the steel roller to raise the

press bed toward the scraper. Let us assume that the scraper is about an inch above the tympan after the pressure lever has been pulled into printing position. With the scraper at this height, the press bed and the stone will slide under it if you turn the crank handle, and no pressure will be exerted on the stone. Consequently, no print will be made. To adjust the pressure, release the lever to the upright position, and lower the scraper by means of the adjusting screw in the head of the frame. Lower it until it barely touches the tympan. Then pull down the pressure lever. As you do so, you will feel a slight resistance indicating that stone and backing and scraper have established contact. You still do not know if this pressure is strong enough to take a good impression, but instead of lowering the scraper again at this time, leave it as it is and crank the stone through until the scraper is resting on the opposite margin of the stone. Crank with a slow, steady, continuous motion. Never stop cranking until the scraper rests on the opposite margin of the stone. Then release the pressure lever to the upright position and, holding the tympan to the stone with one hand, pull the press bed back to its original place with the other. Lift off the tympan, and the backing.

You can eliminate a great deal of stooping and bending by the use of chalk marks on the press bed and frame to mark the points where the scraper rests on the margins of the stone before and after the stone is run through the press. Mark the points this way. First, get the stone ready for a print, with paper, backing, and

tympan in place. Then push the press bed forward until the scraper is over the margin of the stone. When you are certain that the scraper will rest firmly on the margin when the pressure is applied, pull down the pressure lever. Before you crank the stone through, take a piece of chalk and make a mark that will form a straight line across the top of the press frame onto the press bed. After that is done, crank the stone through the press to take the print. When the scraper rests on the opposite margin of the stone, and the pressure lever is still down, make another chalk mark across the press frame onto the press bed, to indicate the stopping point. Make this second mark with a different colored chalk than you used to make the first mark that indicated the starting point.

When the backing is new, the print will usually come off with it. When the backing is old, the print will generally remain on the stone. Use your thumb and forefinger to lift the print. Grasp one end of the print and slowly pull it off. If you use a thin paper, a quick pull will tear it, particularly over black parts of the design which are heavy with ink. As soon as you have removed the print, redamp the stone. Do not neglect to do this, as a stone that is left undamped may allow the ink to spread on the design. It just isn't good working practice to leave the stone without a protective film of water. After you have redamped the stone, examine the proof.

You will see that it is light and weak, and that the ink has barely been impressed on the paper. In lithography, light proofs are the usual thing for three or four proofs,

and sometimes more. This is because the stone has to be worked up to taking in and giving off the ink. In this particular case you have inked the stone lightly, and have used a light pressure in printing, and the result is a light proof. Set the proof aside and redamp the stone. Roll the roller over the ink slab to freshen it and then ink the stone. Be sure that you turn the roller in your hands as you keep up a continuous rolling motion. After not more than ten rolls, lift off the roller, set it on the ink slab, redamp the stone, and then roll the roller on the ink slab. Damp the stone again to be sure that there are no dry areas and then ink it. As you roll, exert a slight downward, sideways pressure toward your body on the roller handles. This pressure will help the ink to take on the stone. As you roll you will see the design taking the ink. You will notice, as the rolling continues, that the light parts of the design take the ink more quickly than do the blacks. Roll the stone with three inkings, then roll the roller on the ink slab. Fan the stone dry and place another piece of printing paper on it. Place the backing and the tympan over the stone and push the press bed into printing position under the scraper.

As you now know that the pressure used on the first print was too light, turn the adjusting screw about a half turn to lower the scraper. Pull down the pressure lever. You will feel a greater resistance than before, but if it is still a weak resistance that allows you to pull the lever down with practically no effort, release the pressure lever and turn the adjusting screw about a quarter

turn more. When you pull down the pressure lever you will feel a stronger resistance than before. This pressure may still not be strong enough to give a full impression, but as the stone is not yet completely up in ink to the strength of the drawing, you will not have a good proof even if you should use a strong pressure at this time.

What you are doing is this. You are building the stone up with ink until it takes a full charge and will reproduce the design on paper in exact proportion to the drawing that was made on the stone. You are using a pressure that is being slowly increased to compensate to the strength of the ink on the stone. Crank the stone through the press, release the pressure lever, and pull back the press bed. Remove the tympan, the backing, and the proof. Damp the stone. Compare the second proof with the first one. You will find that it is richer in color but that the blacks have not yet received a full charge of ink. Damp the stone.

At this point it usually is necessary to add more ink to the roller, as the first charge of ink was not a heavy one. Take up about ¼ teaspoon of worked ink on the ink knife and spread it on the roller. Then roll the roller on the ink slab until the ink is well distributed. Redamp the stone and ink it. This time you will see that the stone is taking the ink more readily than it did before. Remember to damp the stone between inkings. After you finish rolling, for this third proof, the design should seem to be fully inked, with all parts having the strength of color they had in the drawing. Dry the stone, roll the roller on the ink slab, place paper, backing and tympan

on the stone, and turn the adjusting screw another quarter turn to lower the scraper. The resistance on the pressure lever will be quite firm. Crank the stone through the press, release the presure lever, pull the bed back into position and remove the tympan, backing, and print. Damp the stone.

This third proof will be quite rich and full, and a fairly faithful print of your drawing. Compare the three proofs and see how they have gained in intensity as the printing progresses. This progressive gaining in richness will stop when the design has taken as much ink as it can hold.

Remember to keep the stone damp while you are examining the proofs. Roll the roller on the ink slab, damp the stone, and then ink it. When the design is fully inked, take another proof, without increasing the pressure. When you examine this last proof and compare it with the others you will see that it is the best of all, full and rich in color. Then damp and ink the stone until you get a full inking of the design.

This point in the proceedings, after the design on the stone has been brought to the point where it takes a full load of ink and prints it on paper, is a good time to clean the stone in order to print an edition of clean impressions. You may have made experimental tests of crayon on the margins, that will have taken ink. The roller may have gone over the edges of the stone when you were rolling and deposited ink on them. You may find places in the design that you want to correct by scraping. You will probably also want to square the

edges of the design. This is a good time to do these things. The first thing to do is to roll the roller on the ink slab and then set it away in its holder, as you will not need it for a while.

Take up the metal carpenter's square (you can procure it at any hardware store), being sure that it is not greasy, and lay the long side of the square along the top edges of the design so that the short side will form a right angle coinciding with the top and right edges of the design. Arrange the square so that its outside edges are lined up with the edges of the design, allowing the parts that are to be eliminated to protrude from the outside edge of the square. Then wet the sponge and wet down the area between the margin of the stone and the square. After you have done this, take up a stick of snake slip and rub it on the inked part that is to be eradicated. Guide it by the outside edge of the square in the same way that you rule a line with a pencil and ruler, only do it slowly and firmly. As you do this you will see that the snake slip rubs away the ink and leaves the stone clean. After you have gone over the line once or twice, wash away the snake-slip residue without moving the square.

This will allow you to determine the effectiveness of the snake-slip application. If the line is not completely clean, keep rubbing with snake slip and washing with water until it is. Lift the square from the stone, and wet the entire stone to keep it from drying. Then swing the stone around, lay out the square on it and snake-slip the remaining edges. Lift the square from the stone and set

it aside. Wash the stone with water and then use snake slip and sponge to clean the margins and edges of the stone of experimental crayon marks, finger marks, and ink.

After that, examine the last proof for traces of little round black spots. Dandruff may have fallen on the stone during drawing, taken ink, and printed. If you find any of these spots on the proof, locate them on the stone. If there is room enough to use a sharpened snake slip without disturbing any parts of the design, it can be used to take out these spots. If you feel that it is not safe to use the snake slip, the sharpened point of an old dentist tool or the point of a razor blade can be used to make the correction.

You may want to make a correction by scraping out part of the design. Do the scraping with a razor blade or any sharpened tool. If the area is large, and you want it to be white, use the snake slip. Make corrections with the sponge under your hand to avoid smearing the ink. When all the corrections have been made, wash the stone with water. Then wash the sponge of all traces of crayon, ink, and snake slip, and do the same to the pans. Place clean water in the pan you use for the damping water. Wash the stone with clean water. Pick up the roller, roll it on the ink slab, and then roll it on the stone once or twice to make the water lie down in an even film. Roll the roller on the ink slab and set it aside. Then dry the stone.

Whenever you make corrections on the stone with any sharp instrument, or clean the margins with snake

slip, you destroy the gum arabic protection on those parts of the stone. This destruction unseals the corrected parts and makes them once more receptive to grease. If they are not resealed, they will take ink from the printing roller and will print. To prevent this, you must reseal the corrected and cleaned parts of the stone. As you know, the sealing agent is gum arabic solution. However, as you cannot completely remove every particle of the chemical grease surface by scraping with a razor blade or with snake slip, gum arabic alone will not do the job permanently. Nitric acid must be used with the solution to make an etch. This etch must be stronger than the etch you used to etch the drawing on the stone, because you are not concerned with effecting a chemical change in crayon. You are trying to make the gum arabic penetrate deeply into the stone to form an effective protection that will keep the corrected chemical grease spots from a natural contact with the printing ink. In other words, you are changing a printing part to a nonprinting part by altering its action. Before correcting and cleaning, the corrected parts repel water and accept ink. After correcting, they will accept water and repel ink.

Measure ½ ounce of gum arabic solution into the etching dish. Take the pipette and place 10 drops of nitric acid into the solution in the dish. Put away the acid bottle and pipette, and then mix the etch with the damp acid brush. As you probably realize, this will make a strong etch, too strong to be used on the design. You are not going to etch the inked design. This new

etch is to be used only in etching the corrected and cleaned parts to make them repel ink.

After the etch is well mixed, press the brush against the side of the dish to drain off excess etch. Before you apply the etch, be certain that the stone is completely dry. Fan it dry if necessary. A circumstance of this sort is the only time during printing, except for the occasions when you dry the stone before running a print, that it is necessary to have the stone dry.

When an etch is applied to the margins after corrections are made, a dry stone will allow it to form a wall of effervescent bubbles between the parts to be etched and the inked parts, in this case the squared edges of the design. Etch the squared edges by beginning at the right-hand side of the stone. Start brushing a line with the etch about 1/16 inch away from the edge of the ink. The wall of effervescent bubbles will start to form immediately, and will follow the brush as a wake follows a ship. Guide the brush so that the bubbles of etch meet the inked edge of the design. If by a slip of your hand, the etch creeps onto the design, wipe it away immediately with the wet sponge. Wash the sponge to free it of acid, dry the stone, and try again.

When you have etched one edge, turn the stone until one of the other unetched edges is on your right. Etch that edge and then etch the other two edges in the same way. After the squared edges are all etched, brush the etch over the cleaned parts of the margins and edges of the stone. Allow the etch to dry on the stone. If it is not allowed to dry, it will not make a good penetration and

the parts may take ink later. Then the job will have to be done again.

This is the way to etch the corrected and cleaned parts that are all on the margin of the stone. If you have made corrections on the design itself, a slightly different method is needed. Let us suppose that you have lightened a tone by scraping lines in it with a razor blade or other type of scraping tool, or that you have scraped out dandruff spots. White scraped lines will be present in the body of the tone. You cannot use the etch directly on the white scraped lines without getting some of it on the inked parts of the design that are to remain unchanged. The etch will tend to destroy the inked parts, as they are less resistant to the etch than the original crayon was. To avoid this, pour a little gum arabic solution on the stone to cover the entire part of the design in which the corrections are located. Then dip a small water-color brush into the etch, and etch the scraped lines through the gum. As soon as you see the effervescence begin, wipe the etch and the gum solution from the design with a wet sponge.

This etching through the gum solution will usually keep the scraped parts from taking ink, as the blade will have scraped through the gum protection when you made the correction, and exposed the stone. These exposed parts have no resistance against nitric acid and are etched quickly. The action of the etch is meant to attack the incised, exposed lines and prepare them against receiving grease. Make this type of correction and etch it

before you etch the squared edges and the cleaned margins.

If you correct the body of the design with snake slip, always wet the stone with water, as snake slip does not clean effectively on a dry stone. As you make the corrections, keep washing away the residue of the snake slip with the sponge and water. When you have finished the corrections, wash the sponge and then wash the stone with clean water. Dry the stone and pour gum arabic solution over the corrected parts and the surrounding parts of the design. Then etch through the gum with the small water-color brush. When effervescence begins, wash the etch and gum solution from the stone with clean water and the sponge. If the parts that have been taken out were dark or black, repeat this etching procedure to make sure that the corrected parts will not take ink.

When you have finished etching the corrections that have been made in the body of the design you are ready to etch the squared edges and the cleaned margins and edges of the stone. Etch these parts and fan the etch dry. When the etch is dry, wash it from the stone with the sponge and clean water. It will do no harm if the water and dissolved dried etch mixture touches the design during the washing. As soon as the entire stone is free of the etch, fan it dry and apply a new coat of gum arabic solution. Rub it down with the gum pad and fan it dry. This coating of gum arabic solution serves two purposes. First, it reinforces the action of the etch on the margins and corrected parts of the stone; second, it

strengthens the undrawn parts of the design against taking ink. If the design is washed with a great deal of water, when you are making corrections, some of the gum arabic solution that has penetrated into the stone may be washed away. This weakens the protective quality of the gum arabic preparation. The application of new solution strengthens the old and helps to keep the chemical printing spots where they belong. It is a good policy to allow this new gum arabic solution to remain on the stone for at least twenty minutes after it is dry.

When you are ready to print, wash the dried gum from the stone with clean water, ink the stone, and proceed with the printing.

IX

Printing the Lithograph
(continued)

MATERIALS NEEDED:

> 1 lb. powdered rosin
> 1 ounce powdered alum
> Table glass (tumbler)

There is still another type of correction or addition that can be made on the stone before the final prints are taken. Work can be added with crayon or lithographic drawing ink, called "tusche," to augment the design. You may want to add a figure or another object to embellish your composition, or you may only want to intensify a tone or darken a line. Additional drawing on a stone, after the design has been etched, washed out, and proved, is broadly known as counteretching.

This is the theory of counteretching. You have a stone from which you have just taken proofs. The last proof indicates that the stone has printed an exact replica of the drawing that you made on it with crayon. Upon examining the proof, you may want to improve the

composition by additional lines or tones on the original drawing on the stone, to make the lithograph a more complete expression of your creative idea. As you know that the stone has been sealed by the gum arabic solution against receiving grease, your first thought may lead you to make the additions on the prints with crayon. This can be done, and many artists have drawn additions on the prints, usually when only a small change was contemplated, and when only a small edition was taken from the stone.

If you are not quite satisfied with your drawing, and want to add a great deal of work, it would better serve your purpose to grain the stone and do the whole job over again. You may not want to do either of these things but still would like to add some work to the stone. The problem is how to resensitize the stone again to make it receptive to lithograph crayon or ink. The only way to do this is to destroy the gum arabic preparation that has penetrated into the stone. When this is done, the stone will take in grease as it did before it was etched. This is how to do it.

If you want to add work with the crayon or with tusche, with pen or brush, be sure that the stone is inked to the full strength of the design as though you were going to take another proof. This is to be done after you have taken a full rich proof from the stone. After the stone is inked, fan it dry. Place the roller in the holder, as you will not use it for a while. When the stone is completely dry, dust a film of the powdered rosin all over the stone with a small pad of clean cloth.

You will see that the rosin powder will stick to the ink on the stone. As printing ink is not so resistant to acid as crayon, rosin powder must be applied to strengthen the ink. This is necessary as we will have to re-etch the stone later on. Rosin powder can be obtained from lithograph supply houses. Dust excess rosin powder from the stone and then gently wash the stone with a damp sponge. The rosin will not wash from the inked lines. The washing will clear the stone of any free rosin and will allow you to see the design clearly.

When this is done, proceed with all corrections that involve the use of snake slip and scraper. When the corrections have been made, clean the sponge and water pan and wash the stone with clean water. Do not re-etch or gum the corrected parts at this time. After the counteretching and addition of crayon work, all corrections can be re-etched during one etching operation. When the stone is washed, allow it to dry while you mix a saturated solution of powdered alum and water. Mix this solution by first half-filling a tumbler with water. Then take about ½ teaspoon of the powdered alum from the box. You can buy powdered alum at any drugstore. Get a small quantity; one ounce will last you for a long time. Pour ½ teaspoon of the powdered alum into the water and stir until it all dissolves. If, after three or four minutes there is still some alum undissolved, you will know that the water has taken as much alum as it will, and that you have a saturated solution. If all the alum is taken up by the water, add a little more powdered alum until, after stirring, a slight residue is

visible on the bottom of the glass. The stone should be dry by this time. If it is not, fan it dry.

You will now have a dry stone before you on which all corrections have been made with the snake slip and scraper. The saturated solution of alum is ready, and the water pan and sponge are clean and ready for use. Take a small water-color brush and paint the alum solution over the places that you want to resensitize. Be careful not to get the alum solution on places that you do not want to draw on. Allow the alum solution to remain on the stone for three minutes, and if you cannot wash it off the stone, without going over parts of the design that have not been counteretched, take up the alum solution with a piece of blotter, and then wash the counteretched place with water. Dry it.

It is a good plan to counteretch only one part of the design at a time. This will prevent accidental spreading of the counteretch to other parts. After all the places that you want to draw have been counteretched, washed with water, and dried, you are ready to draw with lithograph crayon. Sharpen the crayon and draw. Be careful to keep your hand away from the inked design. Use the drawing bridge or several sheets of paper for a hand rest. As you draw on the counteretched parts of the stone you will feel the crayon slip over the stone. The feeling of the crayon on the stone will be smoother than it was when you drew on the freshly grained stone. When the stone was etched, the nitric acid polished it by its action on the grain, and made it smooth. This smoothness may give the newly drawn lines a slightly

thicker appearance on the print than the original lines have.

If you want to work all over the stone, the best thing to do is to flow the alum solution on the stone with a fairly large water-color brush. Allow the solution to remain on the stone for three minutes and then wash it off with clean water. Dry the stone and make the additions. The alum solution has no etching powers on the stone. All it does is shrink the gum arabic that is contained in the stone, destroy the gum arabic protection, and resensitize the stone to allow it again to receive grease. Do not wash the stone with water after the drawn additions have been made. The newly applied crayon is soluble in water, and will dissolve and wash away. To make the crayon insoluble, and to close the stone against grease, you follow the same procedure as you did when the drawing on the stone was etched. However, conditions now are different and a variation of the etching process must be used. This is what you have. First, you have cleaned the margins and the edges of the stone with snake slip and these parts require a fairly strong etch to keep the cleaned areas from taking ink. Second, you have scraped the design, exposing parts of the stone. These scraped parts must be protected by gum arabic to keep them from taking ink from the roller. Third, you have destroyed the gum arabic protection on the counteretched parts of the design and a new gum arabic protection must take its place. Fourth, the new crayon on the stone must be

made insoluble and the soap content must become allied with the stone to form chemical printing spots.

As the stone has been etched before, the grain has been melted a bit by the acid. If you use too strong an etch when you re-etch the stone, it will melt away the grains and with them the printing spots. Too weak an etch may allow the scraped parts to take ink. Proceed as follows: First, mix a weak etch of 1 ounce gum arabic solution to 10 drops of nitric acid. When it is mixed, set it aside. Second, pour ½ ounce pure gum arabic solution on the margins of the stone and spread it all over the stone by pushing it with the edge of your hand. Do not rub it in. Just flow it on until the entire stone is covered. Then dip a small water-color brush in the etch and apply the etch through the gum arabic solution to the scraped parts in the design. Etch until the effervescent bubbles appear. Then brush the etch away, dip the brush into the etching dish, and etch the part again. When the bubbles begin, brush the etch away, and pour a drop or two of gum arabic solution over the part you have just etched.

Proceed in this way until all the scraped parts are etched. Then etch the new crayon. This is done with the same strength etch. If the crayon you have drawn with is a No. 4, two applications of the etch will be enough. If you have drawn with a softer crayon, more etch will be needed, say three applications for a No. 3 crayon and four for a No. 2. When you have completed the etching of the corrected and added parts of the design, add 5 or 6 drops of acid to the etch in the

dish. Then, after mixing it thoroughly, etch the edges
and the margins. This etch will be stronger, and you
should allow it to remain for at least five minutes. By
that time all the strength of the acid will have been ex-
pended, and you can wipe the etch and gum arabic solu-
tion from the stone. If the margin etch should mix with
the gum arabic solution on the design, it will not do any
harm. You will now have a thick coating of gum and
expended etch on the stone. The best way to get it off
is to push it over the edge of the stone, with one hand,
into the etching dish, held in the other. When you have
removed all you can this way, blot the stone with news-
print, not newspaper because of greasy ink, rub it down
with the gum pad and fan it dry. Then remove the
stone from the press bed. Clean the bed with water, and
wash out the sponge and water pans. When the press
bed is dry, replace the stone. Allow the dried gum
arabic solution and etch to remain on the stone for at
least a half hour. If you like, you may keep the stone in
this state overnight. While all the chemical reactions
take place immediately, experience has shown that better
results can be obtained if the stone rests under the etch
and gum for some time. Usually the longer the better.

When you are ready to print again, treat the stone as
though you were just beginning to print. Wash off the
old etch, and then pour a gum arabic solution over the
stone. Rub it down with a clean, dry gum pad and then
dry it. Next sprinkle turpentine on the stone and wash
it out with the turpentine pad. Be sure that the turpen-
tine pad has no water on it. While the turpentine is still

wet, rub a corner of the pad on the ink slab to pick up a little fresh ink. Then wipe the ink into the turpentine on the stone with the pad. Fan the turpentine dry, and then wash off turpentine, dried gum, and ink with the sponge and clean water. Squeeze the sponge and wash the stone with fresh water. Take excess water from the stone and leave it in a damp condition ready for rolling. You will see that some of the ink you have rubbed on the stone with the turpentine pad has adhered to the design. This "rubbing up" strengthens the added drawn parts, and gets the entire design into condition to take the ink from the roller with a minimum of rolling effort. Some lithographers use liquid asphaltum in place of ink to rub up the design. However, the ink serves the purpose quite as well in this instance.

After the stone has been damped for rolling, freshen the roller on the ink slab with a few quick passes, and ink the stone. Do not attempt to force the stone to accept the ink too quickly. Ink the stone with three separate series of rollings, and then take a proof. As the press pressure is right for printing, this first proof will be better than the first one you took before you made the corrections. Ink the stone and take another proof. If this proof seems to be full and rich, you may consider it a good one, and it may be called the first print. On the next inking, give the stone only two series of rolling. If you continue inking the stone with three series of rolling you may overload the design. If you do, the chemical printing spots will not hold the ink and it will over-

flow and cause fuzzy, dark, lifeless prints. A good rule to remember when you are ready to run the entire edition, after all the preliminary work has been done and the first good print has been taken, is this. Print with as little ink as possible on the roller, damp the stone with as thin a film of water as you can, use just enough press pressure to take a good impression, and have the paper just damp enough to take a good print. In other words, do not overload the roller with ink, do not ink the stone too heavily, do not use more pressure than it takes to get a good impression, and do not have the paper too wet or too dry.

When you are ready to run the next print through the press, simply push the press bed forward until the first set of chalk marks on bed and frame meet to form a straight line. This will indicate that the scraper is in position over the margin. Crank the stone through the press and stop when the second set of chalk marks meet and form a straight line. This will indicate that the scraper is resting on the opposite margin of the stone and that it has taken the print. Release the pressure and take the print from the stone. These chalk marks will save you the trouble of bending over to see if the scraper is in proper position over the margin before you take the print.

When you have taken several good impressions, do not forget to place the prints between blotters that have been prearranged in a stack. This will keep the prints from drying unevenly. Each time you take a print, place

it in the stack of blotters after you have examined it. When you have finished printing, arrange the prints in the blotters so that two prints will be sandwiched between two blotters. Build up the stack of blotters and prints in one pile and then weigh it down with a sheet of metal or plate glass. After the prints have been in the blotter stack for about three hours, remove them and restack in dry blotters. Cover this new stack with the sheet of metal or plate glass and leave them to dry overnight. The next morning they will be dry, flat, and without wrinkles.

If your prints should happen to dry wrinkled, you can flatten them out by ironing the backs with a warm flatiron. If this does not work, the only thing to do is to redamp the prints and restack them in blotters.

Another way to dry prints is to tack each print to a wooden board using about twenty thumbtacks along the edges of the paper. The tacks will hold the paper firm as it dries and will prevent wrinkling.

A portfolio will keep the prints flat if you want to store them. Do not stand the portfolio on edge. Keep it flat on a shelf, and the prints will be at their best when you want to show them.

Mat board suitable for exhibiting your prints can be obtained from your paper supply house. Samples of board will be sent to you upon request. You can best cut the mats on a sheet of plate glass, with the aid of the steel carpenter's square and a single-edged razor blade. If you want a hinged mat, use two pieces of the mat

board. Scotch tape makes a good hinge for the front and back pieces of mat board.

Lay on a table two pieces of board that have been cut to 14¼ x 19¼ inches outside measurements. Then cut the surface of one of the boards to make an opening for the print. After that is done, attach the two pieces of mat board to each other by first laying each piece on its back with the face of the front board down. Then move the boards until the edges meet. Cut a piece of Scotch tape the length of one board and attach it to both boards to allow half the width of the Scotch tape to stick to each board. This will make a hinged mat. Then cut two small pieces of the tape and attach the print by its top edge to the back board of the hinged mat. This will allow the print to hang without wrinkling.

Now you have carried a lithograph through all the processes from graining the stone to matting the completed print. However, you have only started your work in creative lithography, because you have merely drawn with the lithograph crayon, with perhaps a scraped tone or line. There are other ways to draw a lithograph which will allow you to express with great freedom the creative impulses that compel you to set down your ideas and reactions. Lithography is not confined to drawing on stone with a crayon. If you should make a satisfactory drawing on paper with a lithograph crayon, you can transfer it to a stone and take prints from it. You can draw with pen and ink; you can rub a tone, you can draw from black to light, by scraping; and you can make lithographs in color. And when you

make a lithograph, no matter how you draw it, you are not merely producing a drawing by means of a printing medium. You are creating a print that, by means of lithography, has a quality and beauty that cannot be had by the use of any other method of the graphic arts.

X

Printing Troubles and How to Cure Them

There will be times when the running of an edition of prints will not go along smoothly. Troubles do develop even with the best of lithographers, and the way to solve each troublesome occurrence lies in knowing what to do, and how to do it.

Suppose we begin by assuming that you are printing and that you have taken proofs, corrected errors on the stone, re-etched, washed out, and rolled it in ink. Let us further assume that you have taken three prints, that each one is light, and that you have difficulty in getting a full, rich impression. The first impulse is to increase the press pressure but, as you have taken a good proof before correcting the stone, it is possible that the trouble is elsewhere. First, you may not have enough ink on the roller. To test this, take about ¼ teaspoon of worked-up ink on the ink knife and spread it on the roller. Then distribute the ink by rolling on the ink slab and, when it is completely distributed, ink the stone. Then try an-

other print. If this print is richer than the others, you will have solved the problem. If the impressions are still light, the trouble lies somewhere else.

Second, the ink may be too stiff. If an ink is too stiff, it holds back from a complete inking of the stone. To remedy this condition and to soften the ink, the use of lithographic varnish in the ink is indicated. First scrape down the roller and scrape the old ink from the ink slab. Then drop some lithographic varnish No. 3 (medium), about the size of a large pea, on the ink slab near the worked-up ink. Mix the ink and the varnish thoroughly and then spread the usual amount of ink on the roller with an ink knife. Distribute the ink on the ink slab, and then ink the stone. After two or three prints, the impressions should be full and rich. If they are, continue printing. If they are not, the next thing to do is to make certain that you are not using too much water to damp the stone. Too much water, as you know, will prevent the ink from complete contact with the stone. If the water film is all right, still another cause may be the compression of the backing material by the press pressure. You may either use new backing or lower the scraper a hair's turn to compensate for the thinness of the backing. Take the next print, and this one should be right. If it is still too light, examine the printing paper. If the paper is too wet, it will not take up all the ink from the stone. When paper is too wet, you can dry it by taking one sheet at a time from the damp press and placing it on a dry blotter while you are inking the stone for another print. Take a print, and if this one is still too

light and the paper is still too wet, wave the next sheet gently in the air for a minute or two, and it will take a good impression. Paper that is too dry also will cause light prints. When paper is too dry, keep it in the damp press until it is evenly damped.

As you can see, the trouble causing light prints can be laid at the door of the ink, the damping water, the backing, the paper, and the pressure. When light prints occur, examine all these conditions, and test them. If light prints are caused by overetching the stone, there is no absolute remedy that will bring back lost tonal quality. Overetching does not cause light prints of the same variety as does underinking, wet printing paper, and so forth. A print from an overetched stone will usually take ink in spots; some places will be normal while others will be devoid of any tonal quality. Still other parts will have a coarse and sickly appearance. If a stone is badly overetched, the best thing to do is to grain it off and remake the drawing. Stones that are only slightly overetched will sometimes respond to slow, careful inking with an ink that has had No. 3 lithographic varnish added. Take about ten prints from the stone. If the impressions are not satisfactory, give it up, grain the stone, and try another drawing.

Suppose the stone prints too black and each print seems to be darker than the preceding one. In cases of this kind, you can eliminate the printing paper from consideration. Faulty press pressure can be eliminated along with the backing paper. This leaves us three suspects: the ink, the roller, and the stone. As up to this

point you have been using the ink without added varnish to soften it, the ink can be eliminated unless you have been using too much on the roller. That can be determined by scraping the roller free of ink. Then scrape all the distributed ink from the ink slab. Place fresh ink on the roller, distribute it on the slab, and ink the stone. Take two prints, and if the second one is lighter and clearer, you can proceed with the printing, for you have solved the trouble. If the second of these two prints is still too dark, the trouble is still there but it may not be caused by the ink. That leaves the roller and the stone.

If the roller has not been rolled and scraped long enough before you print, it will continually force ink to the stone. When a roller is in good condition, it will not only give the design its full quota of ink, but if by backward pressure on the handles of the roller you have forced too much ink on the design, the roller will pick up the excess ink on its forward roll. The only way to correct inefficiency on the part of the roller is to roll it in the ink on the ink slab for about a half an hour, then scrape it down, scrape the ink slab, add fresh ink to the roller, and roll again for the same length of time. This rolling on the ink slab, scraping, and adding fresh ink will get the roller in good condition.

However, before the roller can definitely be established as the cause of the trouble, the stone itself must be examined. While the trouble can be caused by a roller in poor condition, it can also be caused by the use of a stale or weak gum arabic solution which does

not seal the stone properly. It might also be caused by underetching, and by neglect in keeping the stone damp. As you have probably used fresh gum arabic solution of a good consistency, and have kept the stone damp, the trouble may lie at the door of too much deposited ink on the stone or underetching, or both. To determine which it is, proceed as follows:

At this point you have just taken a print, and the stone is uninked, but there is still a layer of ink over the design, that has not been pulled off by the paper. This must be taken off before you can go ahead. After the last print, do not ink the stone for another. Instead of inking, place an old proof on the stone and run it through the press. This may pull off the excess ink from the stone. Then ink the stone and try another print. If it is all right, proceed with the printing. If the next print is no better than the others, still another remedy must be tried.

We will want to clean the stone of all ink that may be on it, in order to expose the chemical printing spots to a fresh supply of ink to test the condition of the roller and the etched condition of the stone. We propose to do this by washing out the stone, and re-inking with fresh ink. As the stone is not in a good state, gum arabic solution cannot be used on it at this time. The washing out will have to be done with water and turpentine. This can be done as there is no soluble crayon on the stone. There is only ink, which is insoluble in water. When you wash out with water and turpentine, the water protects the undrawn parts from taking grease,

and the turpentine dissolves the ink. Then both water and turpentine are washed from the stone with water. This is the way to do it:

First, be certain that the roller and the ink slab have been scraped down and that fresh ink has been applied to the roller and distributed on the slab. Then cover the stone with clean water. Do not damp the stone—wet it. As soon as the stone is entirely wet, sprinkle about $\frac{1}{3}$ teaspoon of turpentine on top of the water, all over the stone. Within a few seconds after you do this you can see the turpentine dissolving the ink. As soon as this happens, take a clean pad of cloth that has not been used in either gum or turpentine and rub it gently all over the stone. This action will dissolve all the ink, and as soon as it does, wash the stone with clean water. Squeeze the sponge in the slop pan, and wash the stone again until there are no traces of the turpentine. Do it quickly. Take as much water from the stone as you can and then roll it with ink. Roll the roller quickly at first and then slow the rolling motion. Do not roll a long time. This will avoid complete evaporation of the water, which would allow the stone to pick up ink by mechanical adhesion. If the stone does dry out and ink is picked up, you must immediately wet the stone with water, sprinkle turpentine on it, and wash it out again. Then roll it with ink. Ink the stone with two rollings, and take a proof. Then ink the stone with two more rollings, and take another proof. Ink the stone the same way and take a third proof. After the third proof, ink the stone, but do not take a proof. Examine the stone carefully to see

if it looks right in the inking. It should appear clean and clear all over. This examination can be aided by the use of an engraver's or a reading glass of a three- or four-power strength. Glasses of this sort can be obtained from an optician or a mail-order house. The glass will show each printing spot in clear relief. If the stone is clear and the lines are sharp, take another impression. If this impression seems to be good, consider it a print. Ink the stone again with two inkings and take another print. If this one has not darkened, ink the stone and take another. If this one is good, it would seem that the trouble was caused by overinking the stone, and that by remedying that condition on the roller and by cleaning all the excess ink from the stone your problem is solved.

But after the second proof you may, after examining the stone, see signs of the ink filling up the stone again. In this case there is only one thing you can do, as the indications point to the stone taking ink on undrawn parts, showing a case of underetching with a possible complication of a poorly conditioned roller. Ink the stone carefully until the inking is as sharp and clear as you can get it. Then dry the stone and dust powdered rosin over the design. After that is done, mix an etch of about 10 drops nitric acid to 1 ounce gum solution. Then etch the stone with particular attention to the parts that have overflowed with ink. When the etching is completed, three to four minutes' time should be enough; blot the excess etch from the stone with newspaper, and rub the etch down on the stone with the gum pad. Fan the etch until it is dry, and allow the stone

to remain under the dried etch overnight. This treatment will remedy the underetched condition. You can also work on the roller to make certain that it is right for printing the next day.

When a stone prints blacker and blacker with each succeeding print, you can depend on the condition being caused by one of the three previously mentioned faults: over-inking, underetching, or a poorly conditioned roller. There is one circumstance that may impel a stone that is printing well to go out of control and print darker, and that is allowing it to remain undamped for a long period of time. If you should be called away to do something else, you might happen to leave the stone in a dry condition. If you are to be away for a longer time than it takes for the water film to dry, the best thing to do is to roll the stone with just enough ink to take a print. Instead of taking the print, dry the stone, and apply a thin coating of gum arabic solution. Rub the gum arabic solution down on the stone with the gum pad. Then fan it dry. The stone is now protected and you can let it stand for hours, if necessary. When you are ready to print once more, simply wash away the dried gum with water and a clean sponge. Remove excess water with the sponge and roll the stone with one rolling of ink. Take a print. This print may be darker than the other prints but do not let that worry you. Re-ink the stone and take another print. This print will be the same as the ones you took from the stone before you set it aside under the coating of gum arabic solution.

If you are certain that you will not be away from the stone for more than ten minutes, you may wet the stone, and place a wet thickness of heavy paper over it. Or a wet cloth will serve. The water in the paper or cloth will keep the stone damp until you return. Be sure that you ink the stone before you place the wet paper or cloth over it.

When you return, remove the paper or cloth, remove excess water with the sponge, and roll the stone with one rolling of ink. Take the print. This print may be a little lighter than the others, but this is no cause for alarm. Damp the stone, ink it, and take another print. This print will be a good one. Continue printing. At this point let us assume that you do not have time to take any more prints for the day. If you want to take more prints at a future day, ink the stone as though you were going to take another print. Then dry it and apply a dusting of rosin powder. This application of rosin powder helps to dry the ink and keep it from spreading. If you intend to print within a day or two, you may, after you have dusted the stone with rosin powder, simply coat the stone with gum arabic solution. Rub it down with the gum pad and fan it dry.

If you want to keep the stone for a longer period of time, say from one to six months, ink the stone and apply the rosin powder. Then mix a very weak etch, one that is merely an acidulated gum arabic solution. The proportions should be about 3 drops nitric acid to 1 ounce gum arabic solution. This acidulated solution is not intended to perform an etching action on the stone.

It only helps to keep the ink where it belongs. Cover the stone with this weak etch. Blot it, rub it down and dry it, and put the stone away in a safe place.

It is a good idea to examine the gum arabic coating on a stone that has been laid aside for a long period of time. As you know, the stone will absorb moisture. It may sweat if humidity conditions change too rapidly and, if it sweats, the moisture will dissolve the dried gum arabic, and expose the printing surface to the air. This may cause the ink to spread and darken the tones of the design. If you notice any dampness on the face of the stone while it is laid aside, wash off the old gum or etch and apply a fresh gum arabic solution.

When you are ready to print again, get all the printing materials ready, and then wash the old dried gum arabic solution from the stone. Apply fresh solution, dry it, and then wash the old ink from the stone with turpentine. Dry the turpentine, and then wash the dried gum and turpentine from the stone with clean water. Remove excess water with the sponge. Clean the sponge free of turpentine, and damp the stone with clean water. Roll the stone with ink, take a proof, and continue printing. The first three or four proofs will probably be light. Do not force the stone to take the ink too quickly. When you have taken as many prints as you want, you may ink the stone, dust it with rosin powder, coat it with gum arabic or acidulated gum arabic solution, and keep it for another period of printing.

If you do not want any more prints from this particular design, grain the stone as soon as you have fin-

ished printing. Less time and effort are required to clean a stone that is grained directly after printing than one that has been allowed to stand neglected in a corner of the studio for a month or two.

In printing you may occasionally run into trouble caused by a stone that is unevenly grained. This will be indicated by a light area on a print that has taken the impression perfectly except for this one place. Upon examination, the design on the stone will appear to be fully inked all over. The light area on the print will be caused by a low or hollow area on the stone. There are two ways to remedy a condition of this kind. The first is to add another sheet of backing. You will have to raise the scraper a little to compensate for this additional thickness. The extra backing will allow a little more elasticity between scraper and stone. The pressure can then evenly press the paper into the hollow area. Take a print or two; if they are even in color, you will have solved the difficulty. However, the prints may still indicate the hollow area, and in that case you will have to use another remedy. First, give the stone a partial inking, and then find the hollow area on the stone by comparing it with the print. Take a piece of chalk and mark the press bed near the frame to show the position of the hollow area on the stone. Then outline the stone with chalk to show its position on the press bed. Lift the stone from the press bed and set it aside. Be sure to keep it damp.

After you have done this, take a clean, unwrinkled sheet of newspaper, and cut it to the size of the stone.

Let us suppose that the hollow area is 2 inches in from the right-hand margin of the stone, the one that goes under the scraper first. We want to make a resilient padding of newspaper under the hollow area of the stone to add bulk to the back of the stone. This padding will make the surface print evenly.

Place on the press bed the sheet of newspaper to fit the chalk outline of the stone. Then cut another sheet of newspaper, 1 inch shorter than the first. Place it over the first sheet, matching the three sides that will be under the right-hand margin. Then cut another sheet of newspaper 1 inch shorter than the second sheet. Place this third sheet over the second. Cut another sheet 1 inch shorter than the third and put it in place. You will now have four sheets of newspaper, each shorter than the other, built up like steps with the even ends at the margins nearest the indicated hollow area of the stone.

Carefully set the stone over the newspaper on the press bed. Finish inking the stone and take a print. If the print is even all over, you will be able to continue printing without further trouble from this source. If the print is still uneven, remove the stone, and add another step or two to the newspaper stairs. Take another print. If this is not good, add another step of newspaper, and take another print. This method of backing a hollow area on the surface of a stone from underneath is known as "make-ready." It always works. Use care in building up the make-ready. Do not fail to stagger the newspaper. It will not work if all the sheets are the same size. Do not place too many sheets down at once, and be sure

to stagger them. Otherwise the stone may break in the press, and that would be too bad. You can always tell if a stone is hollow by using a metal straightedge to test it. A straightedge testing is not necessary if you have grained the stone according to directions in Chapter I. A simple way to test with the straightedge is to dry the stone and then lay the straightedge across its face, first straight and then diagonally, to cover all corners and edges. Sight along the surface of the stone, and under the straightedge. If you see daylight between the stone and straightedge, the stone is hollow.

If the hollow area is in the center of the stone, build the make-ready to have the thickness of the newspaper sheets under the middle of the stone. Stagger the news-paper "stairs" in from both ends. Lay a full sheet, the size of the stone, on the press bed. Cut the next sheet 2 inches shorter. Arrange it on the center of the first sheet. The sides of the two sheets will meet but the ends will not. You will have the beginning of a double stair-way, one on each end. Build up the stairs and try print-ing as previously directed.

You may sometimes find that when you damp the stone the water will not lie in an even film, but will form into ridges on the stone's surface. When it does, water will be pulled from the valleys between the ridges, and the stone will be exposed. When you ink, streaks will show on the stone, where the valleys take ink by me-chanical adhesion. This trouble is caused by steam heat that has completely drawn all the moisture from the stone. When you damp the stone, it will drink in the

water so quickly that you will not be able to ink it fast enough; but because there is ink on the stone, the water will be absorbed unevenly, in ridges. If this happens, use more water than usual to damp the stone and ink it just enough so that you can gum it down and set it aside. You probably will be able to pick up the ink that has taken on the stone by mechanical adhesion by the usual method of rolling the stone rapidly. If you cannot, wet the stone and wash it out with turpentine. Clean off the turpentine and roll the stone rapidly. Keep damping and rolling until the stone is inked. Then gum it down with gum arabic solution, dry it, and set it away. Do not use gum arabic solution on the stone while the ink streaks are still there. If you do, they may become permanent. This trouble with damping water and dry stones can be remedied by your setting pans of water on the radiators in the room to intensify the humidity. Keep the room cool. Do not turn on too much heat. Heat and lack of moisture in the air always dry the stones and cause trouble with the damping water. Allow the stone to rest for a day or two while absorbing moisture from the room, and you will have no trouble from this source when next you print.

Occasionally when you are cranking the stone through the press you may inadvertently stop at a point where the scraper will rest on the design instead of on the margin. You may do this in the middle as well as near the edge of the design. This stopping, before the scraper rests on the margin, will cause streaks on the print and on the design of the stone. The print will be

ruined, but the streak on the design can be lifted off by careful rolling. Do not take another print until you are certain that the streaks have been eliminated and lifted from the stone by the roller. You can prevent this trouble by making certain that the scraper rests on the margins of the stone before you begin to crank the stone through the press, and after the scraper has gone over all of the design.

Once in a while you may draw and print a stone that will give only light, unsatisfactory impressions that have a flat, uninteresting tonal appearance. This is caused by a flat grain on the stone. A grain of this sort occurs by graining for too long a period when you are putting the final grain on the stone. A flat grain will not hold the delicacy of the crayon tones, and trouble of this sort cannot be remedied. The only thing to do is to take a few prints for a record, grain the stone, and try again.

Another difficulty in printing occurs rarely but is quite a problem. It usually happens when you have washed out an etched stone and are inking it in preparation for taking the first proofs. This is what takes place. The ink will refuse to take on the design in sufficient quantity to make a full impression on paper, although the design will have some ink on it. You can do all the things that are done to make a light printing stone print darker, but the stone will still refuse to take ink as it should. This peculiar occurrence is different from any you have met with before. A film of some substance or other seems to cover the design and refuses to allow the ink to take. The cause of this is purely speculative. It

may be caused by sour gum arabic solution, impurities in the turpentine, adverse chemical substances in the damping water, or gases in the air that have been absorbed by the stone. If an experience of this sort should happen to you, there is one remedy that will work with a little patience.

As the ink is being kept from the chemical grease spots on the stone by an interposing film, this film must be removed before the ink can reach a full contact with the stone. It cannot be dissolved by water, turpentine, alcohol, or any of the other solvents, but it can be removed by an abrasive. Here is what you can do: Wet the stone with water, and then make a small pad of clean cloth. Damp the pad with water and dip it into some finely ground pumice powder, which can be purchased at a lithograph supply house or at any drugstore. Rub the pumice powder lightly on the stone with a rotary movement, and confine the rubbing to a small area. Rub for a few minutes, then wash the pumice from the stone, and take up a little ink from the slab with the turpentine pad. Rub the ink through the water onto the design with a rotary motion. Stop rubbing the ink on the stone before the water dries.

You probably will be rewarded by seeing that some ink has taken on the design. If the area does not take ink all over, wet the stone and rub it with more pumice powder. Then try the ink again. If the ink takes on all the chemical printing spots, you will have removed the film from this part of the stone. Repeat the process of rubbing with pumice powder and inking by rubbing

until the entire stone is clear of the film. When that is done, clean the stone with water, and ink it with the roller. Take a proof. This proof will probably be ragged. Damp the stone, ink it, and take another proof. This one will be better. Keep on inking the stone and taking proofs until the design on the stone is sharp, clear, and well inked. The last proof may still not be perfect but do not take any more. Ink the stone until it is ready for another proof. After this point is reached, dry the stone, apply rosin powder and a fresh gum arabic solution. Dry the gum arabic solution in the usual manner and allow the stone to rest overnight. When you are ready to print, wash off the old dried solution and apply a fresh gum arabic solution. Then wash out with turpentine, damp the stone, and ink it. You will find that the design will accept the ink in a normal way. When you have taken a good proof, make your corrections, re-etch the corrected parts, and proceed with the printing in the usual way.

Watch out for unsuitable weather conditions. On dry, windy days you may have difficulty in keeping the stone damp. Overcome this condition by frequent dampings. On rainy or humid days, the stone will hold so much water that you will have difficulty in drying it. Overcome this condition by printing while the stone is slightly damp.

On hot days, the temperature will soften the ink and cause the stone to act as though it were underetched. Print in the mornings when it is cool. Do not try to print if the room temperature is above 75 degrees. In

winter, the cold temperature will slow up the reactions of both stone and printing ink. The stone will be reluctant to take ink from the roller and give it off onto the printing paper. Do not attempt to print if the room temperature is below 60 degrees. If the room has been colder than 60 degrees during the night, allow several hours for the stone to adjust itself to a higher temperature before you print. The ideal temperature for printing ranges from between 68 and 72 degrees.

When and if you run into printing trouble, do not allow yourself to become panicky. The only conditions that cannot be remedied are those of bad overetching, flat graining, or a broken stone. As these are definite, accomplished facts, the worst has happened, and there is nothing to do except draw another stone and profit by your experience.

All other difficulties can be overcome. Try to find out what is wrong by carefully examining the proofs, the stone, and all your other printing materials. Track down the trouble by making tests and applying what you know to the problem at hand. The results will be gratifying, for, when you print your lithograph and view the edition of fine prints that you have made, you will know the satisfaction of a complete creative fulfillment.

XI

Other Techniques of Drawing and Printing

TRANSFER LITHOGRAPH

While up to this time you have been drawing lithographs on stone with crayon, there are other methods that can be used. One of the most expressive for the creative artist is the lithographic transfer. By this method you can print a drawing that you have made on paper with a lithograph crayon, retaining all the freedom of an impulsive and spontaneous sketch.

First, make your drawing on paper with any one of the crayons that you like to use. The paper can be any good drawing paper that is not too soft. Commercial transfer papers can be obtained from lithograph supply houses, but they are not pleasant to draw on. Transfer lithographs have been successfully made from drawings on typewriting paper, Manila wrapping paper, newsprint, charcoal paper, in fact, almost any paper can be used for this purpose. One of the best is a paper that is used extensively by typographic printers for taking

proofs from type. It can be obtained from almost any printing shop or from a paper supply house. It has no particular name but is called "proof paper." This paper is white in color, one surface is slick and the other grained. The grained surface is the one to draw on. The paper is almost transparent, takes crayon extremely well, and makes a fine transfer.

When your drawing on paper is completed, the next step in making a transfer lithograph is to transfer the drawing to stone. This is done by placing the drawing face down on a freshly grained stone, and running the stone through the press. The pressure will force the crayon on the paper into a firm contact with the stone. As the stone is receptive to grease, the grease from the crayon will transfer itself from the paper to the stone. Then the stone can be inked and prints taken. That is the theory, and this is how to do it.

First, get all your printing apparatus in readiness. Make a fresh gum arabic solution, damp the printing paper, and ink the roller. After all this has been done, place a freshly grained stone on the press bed. Then, to make certain of complete contact between transfer paper and stone, damp the paper in this way. As your damp press is ready and has printing paper in it, place the transfer paper between two sheets of the damp printing paper, and leave it there for about five minutes. Do not put it between wet printing paper or wet blotters. If you do, the wet paper will dissolve the crayon on the transfer, and your work will be spoiled. After five minutes, examine the transfer paper. If it is slightly

damp, it is ready to use. If it still seems to be dry, allow it to remain between the sheets of damp printing paper for another five minutes. If your drawing has been on paper for longer than a week, it should be damped until the transfer paper is quite flexible. Successful transfers can be made from drawings that have been on paper for six months or even longer.

When the transfer paper is damp, place it in position on the stone, drawing side down. Then lay a sheet of damp printing paper over it as a backing. After that is done, cover it with the usual backing of newsprint or blotter and the tympan. Run the press bed forward until the stone is under the scraper. Be sure that the scraper will go over all of the transfer. Then regulate the pressure until it is as strong as the pressure that you use for printing. Run the stone through the press three times, back, forward, and then back again, as rapidly as possible, taking care that the scraper does not come to rest on the transfer. After that is done, release the pressure, pull the bed back, and carefully lift off the tympan and the backing. Do not take the sheet of printing paper or the transfer paper from the stone at this time. Lift one corner of the transfer paper slightly to see if the crayon has taken on the stone. It probably will have done so to a slight degree, but more contact may be needed to ensure a good transfer.

Before you run the stone through the press again, damp the sheet of printing paper, that is on top of the transfer paper, with the sponge. Do not wet it. This extra dampness will make the transfer paper more pli-

able, and it will release the crayon to the stone more easily. Then replace the backing and the tympan, and increase the press pressure by a hair's turn on the adjusting screw and keep it there. Run the stone through the press six more times. When that is done, pull the press bed back and remove the tympan and backing. Lift one corner of the transfer paper to see if the crayon is heavier on the stone than it was before. If it is, take the sheet of damp printing paper and the transfer paper from the stone. If it is not, replace the backing and the tympan, and run the stone through the press three more times. This is usually not necessary, but can be done if you are doubtful of the result.

After you lift off the transfer paper, you will see that most of the crayon has been pulled from the paper and is on the stone. It may appear to be ragged in places but that will be quite all right. Sometimes, in places that are heavy with crayon, the surface of the paper will tear, and the torn paper will be left on the stone. Leave it there. Do not try to wash it off with water, or pick it off with your fingers. Pour gum arabic solution on the stone and smooth it all over with your hand. While the gum arabic solution is still wet, you can remove any bits of paper that may be on the stone by gently rubbing with your fingers.

Allow the wet gum arabic solution to remain on the stone for about five minutes, then dry the gum in the usual way. After the gum is dry, wash out the crayon with turpentine, and wash the gum and turpentine from the stone with water. Then roll the stone with ink. Be

careful to roll it slowly, and do not allow the stone to dry. After you have inked it twice, take a proof. This proof will be light. Ink the stone again and take another proof. This proof will be better, and the design on the stone will be richer. Watch the design rather than the proofs for complete inking. Ink the stone again and, if the design seems to be fully inked and as rich in color as the original drawing on the transfer paper, another proof is not needed.

Dry the stone and dust rosin powder on the design. At this point, you can make all the corrections that you think necessary. After that is done you are ready to etch the stone. Mix an etch of 10 drops nitric acid to 1 ounce gum arabic solution. Etch the stone in the usual way. Dry the etch on the stone and allow it to remain under this etch until the next day. When you are ready to print again, wash off the old etch and apply a fresh gum arabic solution. Rub down the solution with a clean gum pad and dry it. Then wash out the stone with turpentine and proceed with the printing in the usual way.

PEN-AND-INK LITHOGRAPH

Another method of drawing a lithograph on stone is the use of lithographic tusche (drawing ink). You can draw with tusche with a pen or with a brush to achieve black lines or tones. You may get dramatic effects by drawing the entire lithograph with tusche, or you may use it in combination with crayon. Tusche comes in two forms which can be purchased from a lithograph

supply house. If you intend to use a great quantity of tusche at one time, the liquid form may be the best to get. However, if you intend to use tusche occasionally, it would be better to get the stick form. Stick tusche resembles lithograph crayon, but, as it is very greasy, any mark made with it will print solid black. It comes in sticks about 4 inches long, 1 inch wide, and about ¼ inch thick. To make an ink from the stick tusche, heat a saucer until it is quite warm to your touch. Then rub the stick of tusche into the dish until the tusche completely covers the bottom in a thick layer.

Then add a few drops of water, distilled if possible, and mix the tusche and water thoroughly with your fingers. The result will be a sticky, thick ink. Add another drop or two of water and continue to mix it with your fingers. Tip the dish; if the ink is right it will form a small puddle. If it does not flow easily, add a few more drops of water and mix with the ink. Try it with a pen, and when it is of proper consistency to draw with easily, pour it into a small ink well or other container so that you can dip your pen or brush effectively. This ink will not keep for more than a day or two, and it is a good plan to mix a fresh supply every time you want to use it. A No. 1 crayon mixed the same way will give you a usable ink, although it is less reliable than the regular stick tusche.

When you apply tusche to the stone with a brush, be sure that you have enough ink on the brush to cover completely the area you are working on. You can ensure this by frequently dipping your brush in the ink.

Exhausted charges of ink on the brush will cause un-
even tones.

You can get a spotty effect with tusche by spraying
it on the stone with an old toothbrush. First, cover with
a paper screen all the parts of the stone that you want
to have clear of the stippled ink. Then take a charge of
ink on the toothbrush and when you rub your fingers
over the bristles, the ink will spray onto the exposed
part of the stone. The farther away the brush is from
the stone the smaller the ink spots will be. A little prac-
tice will be required before you can control the ink
spray effectively. All lithographs drawn with pen or
brush with tusche require a slightly stronger etch than
a crayon lithograph. Tusche is a stronger acid resister
than crayon but an etch of from 15 to 20 drops nitric
acid to 1 ounce gum arabic solution should etch the stone
properly, depending, of course, on weather conditions,
previously mentioned.

WASH DRAWING (LITHOTINT)

You may at times desire to draw a lithograph in wash,
using tusche to obtain tones that range from light to
dark. Any tusche that you use has been designed only
to give solid black tones. To make light or medium
tones you will have to dilute the tusche. This will
change the balance between the inert lampblack, that
is in the tusche to enable you to see what you are doing,
and the grease content. If you like, you can use turpen-
tine or other solvents to mix the tusche, but in all cases
of dilution, no matter what the carrying medium, the

balance between the lampblack and the grease will be disturbed. This is important to know because, when you draw the wash on the stone, it will have one color when it is wet and another, usually lighter, when it dries. You have no way of knowing how much grease is present in the brush stroke or how much of the tone is lampblack. When you ink the stone, the results will usually surprise you by printing either too light or too dark. This method of drawing on stone is not at all certain of results, because the diluted tusche is not easy to control. You can gain control by making many wash drawings on the stone and adapting the medium to your own particular needs in drawing.

Printing the lithotint is another difficult matter. If you treat the wash drawing as you would one drawn with crayon, the entire design on stone will blacken after a few prints, and that will be the end of it. Before you get ready to print, mix a volatile solution of 4 ounces powdered rosin, ¼ ounce pitch, and 1 quart grain alcohol. This solution for use in etching lithotints was invented by Charles Hullmandel, English lithographer, and is described in the records of the British Patent Office for the year 1857. J. D. Harding made many fine lithotints printed by Hullmandel by this process, that are worth close study.

After the rosin and pitch are dissolved, by mixing in a quart milk bottle, and allowing the solution to stand overnight, it is ready for use. If your wash drawing is completed, this is what to do. First, dust the stone with rosin powder and french chalk. Then etch it with a

weak etch of 10 drops of nitric acid to 1 ounce gum arabic solution. Dry the etch and, after it is dry, wash it from the stone with water. Do not wash the drawing from the stone with turpentine. That will come later. Then ink the stone with two rollings of ink or until you notice that some ink has taken all over the wash drawing. When that is done, dry the stone and place it on the graining table in an inclined position. Block it up from behind, if necessary. Then pour ½ glass of the volatile solution into a tumbler and flow it evenly over the entire stone, allowing the excess solution to drain off. Fan the solution dry. When it is thoroughly dry, replace the stone on the press bed and mix a strong etch, consisting of 25 drops nitric acid to 1 ounce gum arabic. Etch the stone for one minute. Wash off the etch with water, and then coat the stone with a fresh gum arabic solution. Dry the solution, and then wash the drawing from the stone with turpentine. Sometimes the volatile solution will go on the stone unevenly; if it does, it will not completely wash from the stone when the turpentine is applied. If this happens, simply wash the stone with pure alcohol, water, and a clean rag. Then wash the stone with water and, after that is done, wash the stone with water and turpentine to remove all traces of the drawing. When the drawing has been washed from the stone, ink the design in the usual way. Take the proofs, and then make corrections on the stone. Re-etch the corrected parts and either continue printing or gum the stone for printing at another time.

This process always works so far as printing is con-

cerned. If tones are too light or too dark, it will be the fault of the uncertain grease content of your washed tones. Only exact experimentation will teach you how to make and apply to stone a diluted drawing tusche that will do exactly what you want it to do. The best way to experiment is first to mix a tusche that you know will print solid black. Then take half the ink and dilute it with 5 drops of water, or with turpentine if you have used turpentine to mix the tusche. Take half this tusche and dilute it with 10 drops of water or turpentine. Dilute one-half the first tusche mixture with 20 drops of water or turpentine. Keep each of the inks in different containers and make your drawing. Wash your brush each time you use a different tusche, to avoid carrying one strength of tusche into another. Keep track of each wash as it is brushed on the stone. Print the stone and observe how each wash behaves. By increasing or diminishing the amount of dilution, you should soon be able to make a wash drawing on stone exactly as you want it to print on paper. You can make your wash drawing in combination with crayon, scraping, rubbing, and pen and ink. If you draw a combination lithotint, etch it exactly as though it were a straight wash drawing.

Rubbed lithograph

Rubbed tones on a lithograph stone print with a soft, blended quality that often is the means of giving you textural variety in a completed print. While an entire

stone can be drawn with rubbed tones, you may at times want to have a rubbed texture on only a given area. There are several ways of rubbing a stone, and the first method is simple. Let us assume that you are drawing on the stone with crayon, and that you have drawn a tone with the point. This tone may seem to be too sharp and definite, and you want to blend and soften it to fit in with the rest of the drawing or to effect a change in the texture of the tone itself. As there is crayon on the stone in the area that you want to blend, the best way to rub the tone is to use a piece of heavy flannel, silk, or a washed chamois skin that has been dried. Fold the cloth or skin around your forefinger and gently rub the crayon with a circular motion. If you rub lightly, the rubbed tone will stay approximately at the same tonal value as the crayon. If you rub heavily, the tone will darken in printing, because the crayon will have filled the valleys that lie between the tops of the grain of the stone.

Another method of rubbing is first to smear a heavy layer of crayon on a sheet of paper or cardboard. Then rub the cloth or skin on the crayon that is on the paper and apply it to the stone. This method is best utilized when you rub on an area that has not been drawn with crayon. By rubbing the cloth on the smeared crayon you can eliminate streaks on the stone, and ensure an even tone. When you apply the rubbed tone, do not rub the crayon on the stone with a continuous rubbing motion. Load the crayon on the cloth with one light

stroke and then apply it to the stone evenly with another light stroke. Reload the cloth with crayon and make another stroke. Keep this up until the tone has reached the required depth.

You can also achieve a rubbed tone on a large area by pulverizing some No. 4 crayon or a crayon made with graphite. Place ½ teaspoon of this crayon powder on the area to be rubbed and then move it lightly all over the area with a piece of flannel that has been folded into a tight wad. Do not try to get the tone by pressing the crayon powder into the stone with the cloth. Simply move it around and around, and in three or four minutes you can dust it away from the rubbed area. If the tone is not deep enough, repeat the application. Do not use a heavy pressure on the crayon powder. That will make the application uneven and the tone will print much darker than you want it.

All rubbed tones will print darker than they appear on the stone. If they are applied with a light touch, they will approximate the rubbed crayon tone. If heavy pressure is used, the printed tones will be dark in proportion to the amount of crayon rubbed on the stone and the weight of the pressure with which it is applied. Rubbed tones can be effectively used in combination with crayon, pen-and-ink, and scraped tones, as they can be etched simultaneously with other drawing methods. If you have rubbed a stone heavily, it would be wise to etch the rubbed area a minute longer than the parts of the stone that have been drawn with crayon to make certain that the tone will not be underetched.

GELATIN LITHOGRAPH

You can, if you like, use the lifting qualities of gelatin to make a lithograph. This can be done by first drawing a series of tones with the flat of the crayon all over the stone. Then trace your sketch with red conté crayon to the sheet of gelatin, which should be large enough to take the design, or you can lay the gelatin on the stone, place your sketch over it and follow the lines with a hard pencil. When you have completed tracing the lines of your sketch, lift the gelatin from the stone. You will see that it has picked up white lines from the crayon tones. This drawing can be etched in the usual way, and it will print perfectly. You can also scrape out more lines with a razor blade, add accents with pen and ink, or intensify the drawing with more crayon. Before you draw on the gelatin, be sure to fasten it to the stone with Scotch tape to prevent slipping. Scotch tape is greasy and should not be fastened on the surface of the stone. Fasten it to the sides.

MEZZOTINT LITHOGRAPH

The mezzotint method of drawing a lithograph is simply a means of working from a dark background up to light tones and lines. The resulting lithograph can resemble a mezzotint, but it usually looks like a woodblock print, and has little of the quality associated with a lithograph. However, as it can be used effectively and is an interesting creative experience, you might like to try your hand at it. Mix a tusche that will print solid

black, and then brush it on the stone to cover the entire area that your drawing will take. Allow the coating of tusche to dry, and then cover the first coat with another layer of tusche. This will ensure an even, black tone. After this second application of tusche is thoroughly dry, rub down the red conté crayon tracing to guide you when you are drawing. Remove the tracing paper. The red conté crayon lines will remain on the coating of tusche. Drawing is done on the stone with engraver's tools, razor blades, and so forth. You can achieve not only lines, but also tones that range from deepest black to white. When you have completed the drawing, this is the way to etch it.

First, dust the stone with rosin and French chalk, and set it in an inclined position on the graining stand, blocking it up from behind if necessary. Then fill a tumbler half full of cool water, and into the water drop 6 drops nitric acid. Stir the mixture and then flow it slowly over the stone. Be sure the solution covers the entire stone. As soon as that has been done, mix another etch of water and nitric acid of the same proportions and pour over the stone. Repeat this process until the stone has received six etches. When that has been done, dry the stone and remove it to the press bed. Then apply a fresh gum arabic solution to the stone. Do not dry the gum solution at this time. While the gum arabic solution is still wet, mix a strong etch of 20 drops nitric acid to 1 ounce gum arabic solution. Etch into the wet gum arabic solution, continuing this etching process for five minutes. When it is completed, blot the excess etch

from the stone, rub it down with the gum pad, and fan it dry. Allow the stone to remain under this dried etch overnight.

When you are ready to print, wash the old etch from the stone with water and apply a fresh gum arabic solution. Rub down the gum with a clean pad, and then wash out with turpentine. Wash the turpentine and gum from the stone with clean water, and then ink the stone with an ink that has no varnish added. Use less ink than usual on the roller. Take three or four proofs, and if the scraped lines and tones show no signs of filling in, you are ready to make corrections. When that is done, etch the corrected parts in the usual way (see page 38, Chapter IV), and then printing the edition can continue. Sometimes the lines and tones on the stone will fill in after the first three proofs are taken. Stones made by this method frequently fill in on the scraped tones because the scraping is not deep enough to allow the etch to penetrate through the heavy acid-resistant layers of tusche. If filling in occurs, the only remedy is to re-scrape the parts that have not stayed clear. Ink the stone, dust it with rosin powder, and make the corrections. Re-etch the stone with an etch composed of 15 drops nitric acid to 1 ounce gum arabic solution. Pour ¼ ounce gum arabic solution over the corrected parts of the stone, and then etch through the gum for three minutes. Blot the excess etch from the stone, rub down with the gum pad, and then fan dry. Allow the stone to remain under this etch for forty-eight hours. When you are ready to print, wash the old etch from the stone

with water, re-gum the stone with a fresh gum arabic solution, dry it, wash out with turpentine, and proceed with the printing in the usual way.

The etching method of using water and nitric acid on the stone is an old one, and is in fact the method that all types of stone lithographs were etched by Senefelder. Water alone will dissolve the tusche, but when acid is present the tusche is not affected. This water-and-acid etching is necessary for this type of lithograph, as the acid acts directly on the tusche without the interposition of the gum arabic solution. The weak etch of water and acid performs the first steps of rendering the tusche insoluble, and attacks the scraped parts of the stone to make them more susceptible to the strong etch of nitric acid and gum arabic that completes the etching process.

Dry-brush lithograph

Tusche can be used in still another way to make lithographs of a different character than those previously mentioned. The dry-brush technique can be utilized in combination with other methods of drawing on the stone, or it can be used by itself to make the lithograph. A damp water-color brush, rubbed on stick tusche and then tried on the margins of the stone, will soon tell you how much water is needed to get the effect that you want. Use just enough water on the brush to dissolve the tusche so that it can be applied to the stone. Remember that tusche is intended to print black. If you

want to get a variation of tones, it would be advisable
to make an experimental stone or two, so that you can
see what happens to the tusche after the drawing is
etched and proofs have been taken. Tusche dry-brush
should be etched with approximately the same strength
of acid that is used to etch pen-and-ink drawings, 15 to
20 drops nitric acid to 1 ounce gum arabic solution. If,
after you have taken the first proofs, the dry-brush
strokes are darker than they were in the drawing, you
can lighten them by careful scraping. Re-etch the cor-
rected parts in the usual way and then continue printing.

These drawing methods can be augmented by any
way of drawing on the stone that might occur to you.
You can rub your fingers in your hair, and then rub
them on the stone to get a different type of rubbed tex-
ture. It is possible to thumbprint an area on the stone
to get a still different kind of effect. You could, if you
like, draw with gum arabic solution on the bare stone,
and after the gum has dried, you can fill in the un-
gummed areas with crayon or ink. Gum arabic could
also be used to make a white stipple effect on the stone
by spraying with a toothbrush if you use it before you
draw with crayon or ink. A heavy black layer of crayon
or tusche on the stone can be drawn into with a brush
charged with a strong etch, and the drawing can be
made by etching away the parts that are to be light.
Instead of using crayon, you could draw with a lipstick,
a piece of castile soap, or anything else that contains
grease. When you work creatively on stone, the me-

dium of lithography is there to fit your creative needs. As each artist has his own individual problems to solve, in whatever way he can, give your imagination full sway when you experiment, and let your conscience be your guide.

XII

Zinc and Aluminum Plates

MATERIALS NEEDED:

Phosphoric acid
Tin shears
Liquid asphaltum
Milk bottle

While the lithograph stone is the best material for drawing creative lithographs, zinc and aluminum plates can be used. For the artist who is primarily concerned with drawing a lithograph on a surface that not only gives him pleasure in handling, but allows him to use his creative expression to the fullest, zinc and aluminum plates can be considered only as a substitute for stone. Metal plates have some advantages over stone. They are thin and light in weight, can be carried about easily, do not break or chip, and require little storage space. The disadvantages of metal plates as compared to stone overrule their lightness, as the color of the plates (zinc in particular) makes it difficult to judge drawing values, no scraping of any sort can be performed, and the metal is not so satisfactory a drawing surface as the stone.

However, many artists have drawn fine lithographs on metal plates, and some prefer them to stone for the sake of convenience. Whether or not you use metal plates in preference to stone depends on what you want to draw and how you want to draw.

Metal plates for use in creative lithography can be purchased from a lithograph supply house in any size you may desire. The plates are grained, and ready for use. When you order zinc or aluminum plates, specify in your order the grain desired. Plates used commercially are not usually adapted for work with crayon and are likely to have too fine a grain. Inform your dealer of your drawing intentions and he will send you suitably grained plates.

It is sometimes less expensive to buy a large metal plate and have it cut to smaller sizes. The dealer can do this for you or you can do it yourself. If you cut the plates to size, use a pair of tin shears. After the plates are cut, shear off the sharp corners to make them rounded. This will keep you from cutting yourself on the corners, and will make the plates easier to handle when you are printing. If you punch a hole in one corner of each plate, you can hang them on a nail for convenient storage.

The zinc plate is the oldest of the metal plates introduced commercially as a substitute for stone. After many experiments, it finally came into its important position in the printing industry with the introduction of the rotary lithographic press. Stones are rigid and have to be printed on a flat-bed press. Metal plates are

thin and can be bent around a cylinder and prints taken as fast as the rotary press will operate. Aluminum plates have replaced zinc on jobs that require long runs of printing coupled with sharp and clear impressions of such printed matter as maps, charts, and so forth. Photolithography enables an original black line or tone drawing on paper to be photographed to a glass negative. Then, after the negative is retouched, a photographic print is made on a sensitized metal plate. The plate is developed, rolled up with ink, etched, and proofs taken on a flat-bed offset press. After the proofs are corrected and corrections made on the plate, it is fastened to a cylinder in the rotary printing press and prints are taken in extraordinary numbers in black and white or in color. This method of commercial printing is unsuitable for creative lithography, as only solid blacks will photograph well. If gradations of color tones are required, a separate tint plate is made from a screen. The size of the dot and the number to the square inch on the tint plate determine the depth of the tone. This is how metal plates are used in almost all present phases of commercial lithography. Practically no original work is drawn directly on zinc or aluminum in the printing industry; only the creative artist keeps alive this particular use of metal plates.

Before you begin to draw a creative lithograph on a metal plate, it is always good policy to sensitize it with a solution of alum and water. If metal plates are exposed to moisture during storage and shipment, they are subject to oxidation which will prevent a proper contact of

the crayon on the plate. Both zinc and aluminum are subject to oxidation and both should be counteretched before a drawing is started. Do it this way. First, cut the plate to the size you want. After that is done, place the plate on the graining table. Then mix a saturated solution of alum and water. Flood the plate with the solution and leave it on for one minute. Then quickly wash the solution off the plate with quantities of cool water. Drain the excess water and fan the plate dry as quickly as possible. If you allow the plate to dry by itself, some oxidation may take place before it dries. Always use a saturated alum solution as a counteretch on zinc plates. You may also use the alum solution on aluminum plates, although a saturated solution of oxalic acid is generally advocated by commercial printers. Oxalic acid comes in crystal form, and a saturated solution is made exactly the same as a saturated solution of alum and water. After you have obtained a saturated solution of oxalic acid, pour ¼ ounce of it into a glass tumbler, and dilute it by filling the glass with water. This will make the counteretching solution. When you flood the aluminum plate with this counteretch, allow it to remain on the plate for at least three minutes. Then wash off with water and fan the plate dry.

Whether you draw on zinc or on aluminum, the processes of tracing and drawing with crayon or pen and ink are the same as those on stone, with these exceptions. You cannot successfully scrape with a razor or any other sharp tool on a metal plate. If you do, you merely score the plate, and ink will take wherever you

have scraped. Wash drawings on zinc or aluminum do not require the Hullmandel method of etching lithotints. Metal plates hold a wash-drawing technique more readily than stone, but care must be exercised when you apply the washes; it would be well to experiment to determine how they will print on paper. Both zinc and aluminum plates are extremely sensitive to grease and you must take the same precautions when you draw on them as you take when drawing on stone. When your drawing is completed, you are ready to etch the plate, but before you go ahead, a brief discussion of etching solutions is in order. In the first place, nitric acid will not properly etch a drawing on a metal plate. Other acids must be used and the basic etch for both zinc and aluminum plates contains acids other than nitric.

As in stone etches, each lithographer has a favorite etch for metal plates. Most of the etches in use were developed for commercial printing, and can be adapted for creative work.

When you have mastered one method of etching zinc and aluminum, you can try others. References will be found at the end of this chapter. Etches used on metal plates in commercial printing are mixed in large quantities and frequently contain a number of acids. Some of the ingredients used are chromic, phosphoric, tannic, and hydrochloric acids, bichromate of potash, and so on. These and other acids are used on large metal plates to meet commercial production needs of long runs of printing. The artist, concerned only with an occasional lithograph on zinc or aluminum, does not require large

quantities of etching mixtures and a simple etch is the best one for him to use.

Probably the simplest etch for zinc is one composed of gum arabic solution and phosphoric acid, mixed as follows:

Dissolve and strain 1 pint gum arabic solution into a milk bottle and then add ½ ounce phosphoric acid. Mix thoroughly and allow to stand a day or two before using.

When you are ready to etch the plate, do it this way. First, dust the plate with French chalk and rosin and then brush 1 ounce of etch over the entire plate. Allow the etch to remain on the plate for one to two minutes, depending upon the amount of crayon that is on the plate. Etching on metal is not the same as etching on stone. On metal there is no effervescence to guide you in determining the strength of the etch. You will have to rely on timing. If you overetch the plate, nothing can be done about it. If you underetch, the plate can be etched again. Some experiments may be necessary until you can determine the exact time required to etch a plate. This depends partly on the kind and amount of crayon used, and partly on the strength of the etch. If you suspect that the etch is too strong, dilute it with gum arabic solution. The best way to find out how the etch works is to make a trial plate or two so that you can become familiar with the metal plates and the action of the etch.

When the time is up, wash the etch from the plate with clean water and apply a fresh gum arabic solution. Rub down the gum solution with a clean gum pad, and

fan it until dry. After the gum is dry, wash out the crayon with turpentine and, while it is still wet, rub the turpentine pad on the ink slab and rub a small quantity of ink all over the plate. Liquid asphaltum can be used instead of the ink. In fact, asphaltum is best for metal plates, as it is very greasy and aids the drawn parts to receive ink. Liquid asphaltum can be purchased at your lithograph supply house. Dab a small quantity on the plate with the turpentine pad. Dry the plate and then wash off the turpentine and gum with clean water. The asphaltum will remain on the design and help the ink to establish a firm contact. Ink the plate and take a proof. Take several more proofs. If they are clear and sharp, continue printing. Build up the plate to printing strength as you do in printing from stone.

While corrections can be made on metal plates with snake slip and water, in a manner similar to stone, it is best to forego corrections as much as possible, for the corrected areas, even after they are re-etched, have a strong tendency to pick up ink. If the design seems to be filling in, test the roller and the ink; if they are in good working order, ink the plate, rosin it, and re-etch with the original etch for thirty seconds. This will clear up the trouble. Then wash the etch from the plate with water, and apply a fresh gum arabic solution. (When washing the etch from the plate it is a good idea to wear rubber gloves.) Dry the plate, and then wash it out with turpentine. Rub it up with asphaltum or ink, and after the asphaltum and turpentine are dry, wash the plate

with water to remove the turpentine and gum. Ink the plate, take a proof, and continue printing.

If you want to add work on zinc, use the saturated solution of alum and water as a counteretch. After corrections have been added with crayon or tusche, dust the plate with rosin and French chalk and pour ¼ ounce gum arabic solution over the corrected areas. Then etch with the original etching solution for one minute. Wash the etch off the plate with clean water. Re-gum the entire plate with gum arabic solution and dry it. Then wash out with turpentine and rub the plate up with liquid asphaltum. Dry the plate. After it is dry, wash off the turpentine and gum with water. Ink the plate and continue the printing.

In printing from any metal plate you must be careful to keep the plate damp at all times. After you have finished printing, you can save the plate for printing at another time by inking it, dusting with rosin or French chalk, and then gumming with a fresh solution of gum arabic. When you are ready to print again, wash off the old gum and apply a fresh solution. Rub it down on the plate, dry it, wash out with turpentine, rub up with ink or liquid asphaltum on the wet turpentine, and dry the turpentine on the plate. Then wash the turpentine and gum from the plate with cool water, ink it, and take proofs.

Aluminum plates are handled exactly as are zinc plates with one exception in the etch. The phosphoric acid is not used full strength. The etch consists of 12 ounces gum arabic solution to 1 ounce of a 20 per cent solution

of phosphoric acid. Dilute the acid with water to make the 20 per cent solution. You can have it made at a drugstore if you like. Etching time is one to two minutes. Some lithographers determine the action of the etch on metal plates by smelling. Do not do this—the metal and acid fumes are not conducive to continued good health. The counteretch for aluminum plates is the oxalic acid solution previously mentioned.

A good commercial preparation for etching both zinc and aluminum plates, known as "Strecker Salts," can be purchased at your lithograph supply house. This preparation contains no harmful acids, and a can of it will last an artist for years. Full directions for using the salts may be found on the package.

Both zinc and aluminum plates must be blocked up for printing on the hand press, as the scraper cannot be lowered far enough to establish firm contact with the thin plates. The best material with which to raise the plate is a lithograph stone. Place the stone on the bed. Make certain that the scraper will pass over the stone properly. Then wet the stone and place a sheet of wet newspaper on it. Next, wet the back of the metal plate and press it firmly down on the wet newspaper with a sliding motion. The air will be driven from the space between stone and newspaper and the plate will adhere without slipping. Cut away any of the newspaper that protrudes from the plate, and you will be ready to print.

When you print from metal, be careful to keep the roller from going over the edges of the plate. If the plate edges are sharp they will cut the leather of the roller.

Keep all your materials in good order, always use fresh gum, and keep the plate damp. If the plate dries while you are inking, you can usually pick up the unwanted ink with the roller, in the same way that you do on stone. If the ink does not come off, you will have to wash it out with turpentine and water.

Transfers to zinc or aluminum are made the same as on the stone. After the drawing has been transferred to the plate, gum it, dry it, and wash out with turpentine. Rub it up with liquid asphaltum or ink. When you use liquid asphaltum, be careful not to use too much. Do not pour it over the plate. Apply a small quantity to the turpentine pad and smear it over the plate; a little asphaltum goes a long way. Wash the turpentine and gum off the plate with water. Then ink the design and, when the design and the proofs are right, dust the plate with rosin and French chalk and etch it with an etch that is a little weaker than the one you used for a direct crayon drawing. The etch can be weakened by the addition of 12 drops of water to 1 ounce of the etch, or it can be diluted by mixing ¼ ounce fresh gum arabic solution to 1 ounce of the etch. As the ink is not so acid resistant as the crayon, cut the etching time by from twenty to thirty seconds.

After you have made several metal plate lithographs, you may like to read the following books for further investigation into the whys and wherefores of metal plate lithography:

Metal Plate Printing for Artists and Craftsman, by C. W. Seward. The Pencil Points Press, Inc., New York, 1931.

Metallography, by Charles Harrop. Rathby, Lawrence & Co., Ltd., Leicester, the Montford Press, 1909.

The Grammar of Lithography, by W. D. Richmond, pp. 139-144. Wyman & Sons, London, 1886.

Handbook of Lithography, by David Cummings, pp. 196-214. Adams and Charles Black, Ltd., London, 1919.

XIII

The Color Lithograph

MATERIALS NEEDED:

Two or three leather rollers for color inks
50 sheets coated paper
1 lb. red chalk powder
Two or three additional ink or palette knives
One or two additional ink slabs
Color inks

PRELIMINARY STEPS

Soon after the discovery of lithography, Senefelder adapted his new process of chemical printing to the reproduction of pictures in color. As time went on, lithography was used to reproduce oil paintings, in black and white and in color, from important private and government collections. These were made to publicize and take works of art into the homes of the people. Later, commercial publishers bought original paintings from artists and these were reproduced by color lithography on paper; as the reproductions were inexpensive, they were available for home decoration. These color lithographs were known as "chromo lithographs" and some-

times the drawing, composition, and color printing of these reproductions were so bad that to this day the word "chromo" is used to designate a cheap and gaudy picture.

Oleographs were another adaptation of the color process of lithography. They were lithographs printed on canvas, and sometimes on cloth, to give the impression that the pictures were original oil paintings. The imitations were usually good, and as the price was low, both oleographs and chromo lithographs soon became familiar sights in almost every home.

In the United States, the firm of Currier and Ives became foremost in reporting news events pictorially, and printing pictures of all sorts of subject matter, by means of color lithography. The vogue of these lithographs continued until the camera took the place of the stone in recording current events. After that happened, color lithography was principally used commercially as a means to reproduce maps, charts, bank checks, letterheads, whisky labels, fruit and vegetable can labels, circus posters, and almost every other kind of advertising reproduction work.

Toulouse-Lautrec in France, in the latter part of the nineteenth century, made a series of creative lithographs in color that stimulated artists to realize the undeveloped possibilities of lithography as a color medium. Soon after the re-introduction of creative lithography in the United States by the pioneer work of Joseph Pennell and Bolton Brown, American artists became interested not only in black-and-white lithography, but in color

lithography as well, as a means of creative expression. Interest in the creative color use of lithography has been steadily growing and the following chapters are concerned with the methods of drawing and printing color lithographs.

Care of the rollers in color printing

To begin with, all the materials that you use in printing a black and white lithograph are used in color printing, along with additional supplies. The most important of these augmented materials is the printing roller. You will need two or three rollers for color, and one roller for black. The black roller that you have used for printing black-and-white lithographs should not be used for any other color. It is advisable to have one roller that will be used exclusively for blue, green, and purple inks, another for red, orange, and brown inks, and still another for yellow and other light tints.

The best rollers to use for color are the same kind that are used for black, that is, grained leather rollers. You can, if you like, purchase a rubber hand roller from a lithograph supply house. Only one of this type of roller is necessary for all color printing, as it can be easily cleaned of ink, with turpentine, between printings in different colors. However, it will not produce so fine a color print as the leather rollers. The rubber roller does not need to be broken in for printing. You simply apply the color on the roller, distribute it on the ink slab, and you are ready to ink the stone.

The leather rollers for color inks must be broken in

exactly as you broke in the roller for black ink, as described in Chapter VI, except that you roll them in color ink instead of black. After the color rollers have taken as much of the No. oo varnish as they are capable of absorbing, they are to be rolled in the stiff No. 7 varnish to remove the excess No. oo as well as the bits of roller fuzz. When the color rollers are in condition to receive the ink, do not roll them with black ink. Instead of black, use the color that will predominate in each roller's use. If you are breaking in the blue roller, use a dark-blue ink; if you are breaking in the red roller, use a red ink.

There is one important point to remember in keeping a color roller in good printing condition. After you have used a color ink on a leather roller, scrape off as much of the ink as you can with the ink knife, and then wash every trace of the ink from the roller with turpentine or kerosene. Gasoline, naphtha, or any other solvent can be used, but they are highly inflammable and their use is not recommended. Turpentine or kerosene will do the job just as well. This washing of the ink from the roller with a solvent is necessary, because color inks purchased from a lithograph supply house contain drier. If the roller is allowed to stand for a day or two without cleaning, the drier will harden the leather, and before you can print again you will have to break in the roller just as if it were a new one.

You can save yourself a lot of time and trouble by cleaning the roller with an ink solvent immediately after you have finished printing for the day. It is also

necessary to wash the roller with turpentine or kerosene when you are changing inks on the same roller. If you have been printing with red on the red roller and then want to print with brown on the same roller, the red ink should be cleaned off with turpentine or kerosene and then, after the roller has been dried, the brown ink can be applied. This washing will keep your colors clean and it will prevent dull, lifeless, and muddy color impressions. If you have ever mixed oil or water color with a dirty brush, you will have noticed that clean colors are almost impossible to obtain if the brushes have been used for other colors and have not been cleaned. Instead of clear, clean color, you usually get a muddy, neutral effect. This same reaction takes place with printing inks. The best way to avoid this loss of brilliance, even if you intend to print with a grayed color, is by carefully mixing the color ink with clean ink knives on a clean ink slab and then applying to a cleaned roller. It is also imperative that the ink slab on which you distribute the ink be washed clean of all traces of old ink.

One or two extra ink slabs will be useful as it is a good plan to reserve the black ink slab for that color alone. You will need a supply of coated paper on which to make offsets for transferring, as well as a pound or two of red chalk powder.

A series of holes drilled through the top of an old table will be useful for storing the rollers when they are not in use. No matter how you store the rollers when you are not printing, it is of the utmost importance to

prevent any surface from pressing against the leather. If you do not take this precaution, the leather will be flattened on one side and you will have difficulty in handling the rollers effectively when you are printing. The methods for setting aside the black roller for future use, discussed in Chapter VI, are applicable to all grained leather color rollers.

A simple ink knife rack can be constructed with a little time and not much effort. This rack will be helpful in keeping track of the knives as well as preventing ink smudges from getting all over everything in the studio when you are mixing color inks (see drawing).

INK KNIFE RACK

A. Wood block with cut out grooves.
B. Board attached to grooved wood block.
C. Ink knives.

The ink knife rack is constructed in this way. Take a piece of wood 2 inches wide, 8 inches long, and 2 inches thick. With a saw cut grooves 1 inch deep across the top surface of the wood. These grooves should be about 1½ to 2 inches apart. The blades of the ink knives are to go into these grooves.

Nail or screw the grooved wood onto a piece of flat board, about 8 inches wide and 8 inches long. This arrangement will keep the knives separate and will prevent the ink on them from soiling paper, blotters, and other materials. If you like, you can nail the rack to the top of the inking table to make a permanent fixture.

COLOR PRINTING INKS

While the color printing rollers are must equipment for printing creative lithographs in color, the printing inks are of no less importance. In the early days of color printing, each lithographer mixed his own inks, as commercial ink manufacturers had not developed ink production on a large enough scale to meet the special demands of the new industry. As in all colormaking, dry pigments were used, and the lithographer made his inks by grinding the pigments in linseed oil varnish. Today, every color ink imaginable can be procured at your lithograph supply house, and the need for grinding your own colors is gone, unless you would like to try your hand at it. Upon request, lithograph supply houses will send you color charts of color inks, price lists, and so forth. When you send for your inks be sure to include white in the order. This color is necessary to opaque transparent inks, and for mixing to get lighter tints of any given color. Your own needs, theories, and attitude toward the use of color in creative work will be the basis upon which you will select your colors. As in oil and water colors, the printing inks are made in both fugitive and permanent colors, depending

on the pigments from which they are ground. As in all creative work, it is advisable to use permanent colors in making a color lithograph; fugitive pigments fade and discolor with age, exposure to light, gases, and mixture with other pigments. Color printing inks are different from the colors used in painting, and even though you know your painting colors thoroughly, it would be wise to study the ink charts carefully before placing your order. If you are doubtful of any particular color as to permanency, transparency, or covering power, state your questions and describe your needs to your supply house, and you will receive full information about the inks. As there are literally hundreds of color inks and tints for you to choose from, it would be well for you to investigate your dealer's supply before buying. Color inks range in price from 50 cents to $3.50 per pound, depending on the color and the pigments they are ground with.

THE COLOR SKETCH

While it is possible to make a color lithograph without any preliminary plan, it is best to make a color sketch in water color, oil, or any other color medium. This sketch should be as complete as possible, to act as a guide not only for your composition in line and mass, but also for the distribution of color in the lithograph. Do not make your first color sketches too elaborate, as you will be restricted by the number of stones that you have on hand and by the time in which you have to make the prints. As each color usually needs a separate

stone and a separate printing, you can see that, if your first attempts are too ambitious, you may run out of stones while you are making your drawings.

Perhaps the best plan is to make your sketch with the idea of having the color lithograph made up of four color stones including black. This means that you will have to prepare five stones, one more than you need for actual printing. This extra stone is called the "keystone." Prints from this stone will be used, after treatment, as transfer offsets which will be laid down on the other stones as guides for your drawings. When you paint the color sketch, it is a good plan to make it the exact size you want the lithograph to be. This is necessary because you will have to trace the outlines of the sketch onto the keystone, and then use the sketch as a color guide when you are drawing the color stones. For commercial printing, the colors in the color sketch are of vital importance, as they are followed and reproduced exactly by the printer. The creative artist, on the other hand, can arrange the colors in his own lithograph any way he chooses, and while the colors in your sketch might approximate your idea of the lithograph in color, you can change them at will to fulfill completely your creative intention.

THE KEYSTONE

At this point you should have all the rollers in printing condition, the color sketch completed, a fresh gum arabic solution ready, clean rags available, and five freshly grained stones large enough to allow for the usual

margins. If this has been done, you are ready to make a tracing of the color sketch in red conté crayon. Make the tracing in the usual way. See that you have a complete line tracing of the sketch. When the tracing is completed, place one of the stones on the press bed and transfer the tracing to the stone, either by rubbing it down with the back of a spoon or by running it through the press. When the tracing is on the stone you are ready to make the keystone. This keystone is an important part of the color lithograph as, by means of the prints taken from it, you are able to draw each color stone in such a way as to enable all the colors on the finished print to occupy the areas where you want them to be.

The keystone is nothing more or less than a means of reproducing a tracing that can be put down on each of the remaining four stones, to make the tracing on each color stone exactly the same as those on the other stones. Let us assume that your color lithograph calls for four-color stones: red, blue, yellow, and black. You can draw each color stone in such a way as to print each color separately, allowing the colors to meet at the edge of each color area, or you can draw the color stones to have some parts of the yellow stone print over blue to make green, yellow over red for orange, and blue over red for purple. To do these things, each color stone must have a tracing that is an exact duplicate of those on the other stones.

By this means you can draw everything on the red stone that you want to have red, orange, and purple.

You can draw lines or areas on the blue stone that are to be blue, purple, and green, and the areas that are to be yellow, green, and orange can be drawn on the yellow stone. The black stone is to be made only for the blacks in the lithograph, although you can draw in areas or lines to print over either one or all the other colors. When you make the keystone you will not only draw the outlines of the tracing, but you will make register marks that will appear on all the color stones so that you can obtain an exact register in printing. This is necessary as each color stone has to be printed separately on the same sheet of paper.

You will first print the full edition plus an additional number of prints, making allowance for spoiled impressions that will have to be discarded. Usually the order of printing the color stones is as follows: Stone #1 (red). The impressions taken from this stone are to make up the required number for the full edition, as well as extra impressions to compensate for imperfect and spoiled prints. After that has been done, print color stone #2 (blue) on the #1 impressions, after which color stone #3 (yellow) is printed on the #1 and #2 (combined) impressions. The black, or #4, color stone will be printed on the #1, #2, and #3 (combined) impressions to make the completed color lithograph.

That is the method of color printing. The first step is to draw the keystone. As the impressions from the keystone will be taken on dry, coated paper, and the inked lines on the paper dusted with red chalk to make the offset transfer, it is not necessary to draw anything but

lines on the keystone. This may be done with pen and tusche or crayon. Make a careful keystone, as the success of the subsequent drawings on the color stones depends on the accuracy of the key drawing and the placing of the register marks. The keystone must be handled as carefully as any other black-and-white lithograph. Use all the customary precautions when you are drawing. It is usually necessary to draw with fairly firm lines to ensure a good body of ink on the coated paper. Well-inked lines will produce sharp, clear, red chalk offset transfers. Poorly inked or weak lines may result in offset transfers that are too indefinite to be usable.

It is a good policy, in drawing the keystone, to outline every object or mass or color that is in the color sketch. Little should be left to your memory, as you may find yourself hopelessly involved when drawing the color stones. An excellent rule for drawing the keystone is this: Make a tracing that will indicate the outline of every object and division of color in the color sketch. Verify the tracing before you make the keystone. After the keystone has been drawn, check the drawing on the stone with the sketch and the tracing, to make certain that you have not overlooked anything. When you have completed the keystone drawing and are sure that it is what you want, you are ready to place the register marks in position.

REGISTER MARKS

Register marks are small crossed lines that guide you when you place the paper in printing position on the

color stones. As the stones have to be printed one at a time, it is necessary to have some sort of guide to enable you to place the paper on each stone in such a way that each color will fit into its designated area without overlapping. If a finished print has overlapped sections of color, it is known as an "off-register" print, and cannot be used. To prevent serious off-registering of the color stones, it is necessary to indicate register marks on the keystone. These keystone register marks will be transferred to each of the color stones by means of the offset transfer, and as they will be in an exact relationship to the drawing on the keystone and to those on the other color stones, a perfect registration of the colors on the printing paper is possible of achievement.

Along with the register marks, it is customary to draw a series of small squares on the keystone, one over the other, for each color to be printed. These squares are drawn in outline on the keystone. If the red stone is to be printed first, you will fill in the first square solidly with crayon or tusche when you draw the red stone. On the blue stone, the second square will be filled in with crayon or tusche, the third square on the yellow stone, and the fourth square on the black stone. As you print, you will be able to see at a glance by means of these squares whether you are printing in perfect register. The squares are used as a double check for registering. Each square will, of course, take the color of its own stone, and if the register is off, you can tell which way to shift the paper to achieve a good register on the next print. The register marks on the keystone are usu-

ally placed near the edges of both margins, on the width of the stone. The squares can be placed on either the right- or the left-hand margin (see drawing).

KEYSTONE DRAWING BEFORE TRANSFER OFFSETS ARE TAKEN

A-A. The register marks.
B. The color indicator squares.
C. The outline drawing on the stone.

The register marks are to be drawn either with pen and tusche or with crayon. The lines forming the register marks should be as thin as possible, and they are to be drawn in this way on the keystone.

First, measure one width of the keystone drawing and locate a point that will bisect it. Then measure the other side of the drawing and locate another point similar to the first. Lay your carpenter's square or a ruler across the stone, lining it up with these two points. Then, with a hard pencil, draw a light line, ½ inch long and 1½ inches in from the edge of the stone. Do this on both margins. Then, through the center of each of these lines, draw another line ½ inch long perpendicular to the first line. This will give you two sets of two crossed lines, one on each margin, 1½ inches in from the edges of the stone. When this has been done, ink the lines with

pen and tusche or draw over them with a sharp crayon.
These crossed lines are the register marks.

Make the squares by ruling two upright parallel lines,
1 inch long and ¼ inch apart, about 2 inches above one
of the register marks. Close the ends of the parallel lines
to form a rectangle. Divide the rectangle into four equal
parts. This will give you a color indicator, consisting of
four ¼-inch squares, one for each stone. Ink the lines
with pen and tusche or draw over them with a crayon,
and the color indicator is completed. At this point the
outline drawing has been drawn on the keystone, and
the register marks and the color indicator squares are in
place.

You are now ready to etch the keystone. The pro-
cedure is the same as for any stone that has been drawn
with crayon or tusche, whichever you may have used.
Refer to Chapter IV, "Treatment of the Stone After
Drawing Is Completed."

THE TRANSFER OFFSETS

When the keystone has been etched, washed out,
rolled up in black ink and several proofs taken, you will
be ready to make the offsets. If any corrections are
necessary, make them in the usual way. After the key-
stone has been corrected and the corrected parts re-
etched, take another proof or two on damp printing
paper until the stone is printing at full strength. When
that has been done, you will be ready to take the offset
prints. As the paper on which the offsets are to be made
is a coated paper, obtainable at any typographic print

shop or paper supply house, the stone must be dry when
you place the paper on it preparatory to running
through the press. If the coated paper comes in contact
with a wet or damp stone, the coating will dissolve and
the sheet will be spoiled.

The sheet of coated paper should be large enough to
take the register and color indicator marks as well as the
keystone drawing. When the keystone is fully inked,
fan it dry, and place a sheet of the coated paper on it.
Use the customary amount of backing and the tympan,
and run the print. While you will need only four off-
sets, one for each stone, it is a good policy to take twice
as many from the keystone. This should be done be-
cause you may inadvertently smudge one or more of the
offsets before transferring, or one of the offsets may
slip while you are transferring it to a color stone. It will
save time and effort to have a good supply of offsets at
hand.

After you have done this, the purpose of the keystone
has been served and it can be regrained and used for one
of the color stones, if you are short of stones. However,
it is a good plan to ink the keystone after the last offset
print has been taken, and gum it down for possible use.
If you intend to make the black color stone a complete
outline drawing, the keystone could be used as the black
color stone and it will save you redrawing another.

At this point you will have a set of keystone prints,
printed in black on a coated paper. This is what to do
to make the offsets. Lay one of the sheets, face up, on a
table and then take 1 teaspoon of the red chalk powder

and sprinkle it on the paper. Take the paper in both hands and sift the chalk on the paper until every bit of the ink is completely covered. Pour the excess chalk back in the can and flip the back of the paper with your fingers to get rid of all the chalk that does not adhere to the inked lines. When that has been done, you will have coated the keystone print with the chalk, and this coating of chalk will make the offset transfer that will guide you in making the color stones. After you have made one offset sheet, do the others in the same way. The theory of the red chalk offset sheets is a simple one. The keystone prints are coated with the chalk to enable you to get perfect tracings that will be exactly alike on each color stone. If you were to attempt to make these tracings by hand, errors might creep in that would make it difficult to get an exact balance of drawing on the color stones. The printing ink on the keystone prints is greasy, and, if transfers were made on the color stones with these prints without a covering of red chalk, ink would take on the color stones where you might not want it. The red chalk offset transfer is the answer to these problems, as the chalk is chemically inert on stone or metal plate.

After all the keystone prints have been covered with red chalk, hang them on nails, to prevent rubbing. It is best to transfer the offsets to the color stones as soon as possible after they have been made. Place a freshly grained stone on the press bed in position for printing. Then lay one of the offset sheets face down on the stone. Place the backing and the tympan over the offset, and

run the stone through the press. When you have re-moved the tympan and the backing, lift off the offset carefully. You will see that the color stone has a red chalk outline that is an exact facsimile of the keystone drawing. Remove the stone from the press and put an-other in place. Take another offset sheet and transfer it to this stone. Do the same with the remaining two stones, being sure to use a fresh offset sheet on each stone. If the offset should smear on a stone, wash the stone with water, and, after it is thoroughly dry, take a fresh offset to make the transfer to the stone. When you have red chalk offset outlines on the four stones, set three of them aside, and cover them with sheets of clean paper. The fourth stone is to be used for making the first color stone drawing.

DRAWING THE COLOR STONES

When you begin to draw this first color stone you must use all the drawing precautions that you use in drawing a black-and-white lithograph. The materials for drawing are the same, as you are to work with crayon, pen and tusche, brush and tusche, scraping tools, rubbing, wash, and so forth. One other drawing material can be used on a color stone, which is not suitable for use on a black-and-white lithograph. This material is rubbing ink. Rubbing ink can be purchased at your lithograph supply house in three degrees. It comes in hard, medium, and soft sticks, about 3 inches long and about ½ inch square. Rubbing ink can be used to rub in large areas for color tonal work. It always prints much

darker in black and white than it appears when drawn on the stone. For color work, this is not a drawback, as you can control the depth of the tone by the color you print with. Rubbing ink is applied by rubbing a cloth or chamois skin on the stick to charge it. When a good amount is on the cloth or skin, rub it on the stone. It is not advisable to rub the stick directly on the stone, unless you want a solid area of color; if this is the case, tusche would be better.

For convenience, let us assume that you will draw and print the color stones in this order: red, blue, yellow, black. You may, of course, print your stones with any color that pleases you, and in any order that you choose, but for purposes of clarification, we shall follow this plan of work.

All drawing on the color stone or plate is done with black crayon or tusche. Then the stone or plate must be etched before the crayon or tusche is removed. After the stone has been etched, the black drawing is washed off with turpentine and, after that has been done, the stone or plate is inked and printed with the color ink. This includes all work in line or in tone. Because of this, it is necessary that you refer frequently to your original color sketch for guidance as to where you are to draw. Wherever there is red in the color sketch you will probably want red to appear in the color lithograph. As you draw, locate all the reds in your color sketch and draw them in their proper places on the red stone. If you want blue or yellow to overprint on the red on paper, you must be sure to draw in the outline of the

color indicator squares and also all the areas that later on will be augmented by blue or yellow. When all the red lines or areas have been drawn in black on the red stone, and you have drawn the areas that will be overprinted by one or more of the other color stones, fill in the first square on the color indicator with crayon or tusche. Then set the red stone aside, cover it with clean paper, and place the blue stone on the drawing table.

The blue stone is to be drawn in a manner similar to the red, except that you must be careful first to draw in all the parts that are to print blue. Then by carefully following your color sketch, draw in the parts that are to print over the red. After that is done, draw in the areas that are to have yellow printed over them. When that has been done, fill in the second square on the color indicator with crayon or tusche. This will complete the drawing on the blue stone, and, after you set it aside and cover it with paper, you are ready to draw the yellow stone.

When you draw the yellow stone, first draw in all the places that are to print yellow. Then draw the areas or lines that are to print over red, and after that draw the places that are to print over blue. Then fill in the third square of the color indicator. This completes the drawing of the yellow stone. Set it aside as you have the others and you will be ready to draw the black stone.

The black stone may have only small areas that you want black, or you may have planned to print some or all the outlines of figures, trees, rocks, or any other objects that might happen to be in your color sketch.

This stone is usually made to tie together by outline the combination of the other colors in the color lithograph. You do not have to use black to do this. You can employ any color you chose, depending on what you have in mind and determined by the way it will fit in with the result that you want. In other words, the outline or drawing stone that is to complete the color lithograph does not necessarily have to be black. It can be any color you choose. You do not even need to have an outline or drawing stone, as you can arrange to draw any or all the outlines on the other color stones. It all depends on what you want in your lithograph. However, for the sake of clarifying the operations of the process, let us continue with the black stone.

If you should want any parts of the black stone to overprint on the other colors, first draw in all the lines or areas that are to be wholly black. When that is done, draw the lines or tones that will overprint, first on red, then on blue, and last on yellow. If some of the overprinted colors (purple, green, and orange) are to have black overprinted on them, draw these lines or areas on the black stone after all the other parts to be overprinted on red, blue, and yellow have been finished. The last thing to do is to fill in the fourth square in the color indicator with crayon or tusche.

This will complete the drawing on all four color stones and you are now ready to etch and prove them. Before you begin this next step, it is always advisable to lay out all the color stones on a table or on the press bed, and check the drawn areas on all the stones with

the color sketch and tracing to make certain that you have not overlooked anything. If you have, this is a good time to find out about it, as after the stones are etched and proved work in crayon or tusche can be added only by counteretching, which should be avoided if possible. While you are examining the stones or plates, handle them carefully to keep them free of finger marks. If you have to make any additions to the stones be sure to use clean paper to rest your hand on while making the corrections.

XIV

Etching, Proving, and Printing the Color Stones

The procedure for etching the color stones is exactly the same as that used for etching a black-and-white lithograph. This is possible because at this stage of making a color lithograph the color stones have been drawn with crayon or tusche and are, in effect, crayon or tusche drawings on stone. When the drawings on the stones are completed, dust each stone with French chalk and etch it, judging the strength of the etch by the amount of crayon on each stone and by the effervescence test on the margins. If you have used rubbing ink for rubbed tones, those areas should be etched two minutes longer than sections that have been drawn with crayon. When all four stones have been etched, you will be ready to take the first proofs. You may, of course, allow the stones to remain under the dried etch overnight or for a longer period, depending on when you intend to print. Have your black roller in good condition and a quantity of paper in the damp press, enough

for the edition. Always damp more paper than you will need, as you may waste some of the sheets when you print the second, third, and fourth color stones.

When you dissolve the gum arabic, in preparation for etching, it would be advisable to prepare a sufficient quantity to make a pint of gum arabic solution. By having this amount on hand you can be fairly certain to have enough in the event that you need to make corrections on the stones after you have taken the proofs. You will require a larger quantity of gum arabic solution than is necessary for a single black-and-white lithograph, as the four color stones can be etched at the same time.

Proving a color stone is always done in black ink, and, after the color stone in black is checked for errors, changes, or corrections the black ink is washed from the stone with water and turpentine and the stone is rolled in color. After the color proofs are printing to the full intensity of the color, the edition of the color stone is taken. The procedure of proving the color stones in color takes quite a bit of time and, as the colored inks have a tendency to dry out after they are mixed, it is best to prove and print only one color stone during a printing session. After a color stone is proved in its color, it is a good plan to run the entire edition of that particular color. The next time you print, you can prove and print the second color stone. If your energy holds up and time permits, you may prove and print the third color stone.

Whenever you are printing in color, and want to set the stone or stones aside for printing at another time,

you must wash the color from the stone with water and turpentine, and ink with black. This prevents the color ink from drying out on the stone and causing trouble in washing out the next time you are ready to print. That is the general idea of proving a color stone and here is how to do it:

THE RED COLOR STONE

At this point, you have etched all the color stones according to the same procedure as previously indicated for black-and-white drawings on stone. (See Chapter IV, "Treatment of the Stone After Drawing Is Completed.") After that is done, set the blue, yellow, and black stones aside, and place the red stone on the press bed. First, wash the old, dried etch from the stone and then apply a fresh gum arabic solution. When that is dry, wash the crayon or tusche from the stone with turpentine and clean the turpentine and gum from the stone with water. Then ink the stone with black ink, just as you do when you print a black-and-white lithograph. After two inkings, take a proof on the damp printing paper. Take as many proofs as are necessary to show that the stone is up to full printing strength. When you have taken a good proof in black ink, examine the stone and the proof for errors or necessary corrections. There may be dandruff spots or fingerprints that need to be eliminated by scraping with a tool or with snake slip. Make all corrections at this time and be sure to re-etch the corrected parts in the usual way. (Refer to Chapter VIII, "Printing the Lithograph.") After that

has been done and the stone is once again in printing condition, take another proof; if it is right, you are ready to prepare to ink the stone with red. Before you begin to mix the red color, gum the stone with gum arabic solution. This coating will protect the chemical printing spots, and the stone will be prepared for washing out with turpentine when you are ready to roll the stone with red ink.

When you mix a color ink, the first thing to do is to take a small quantity of ink from the can and place it on the ink slab that has been reserved for this general type of color ink. You can best approximate the way the color will print on paper by touching the tip of your finger to the ink and then rubbing it on a piece of white paper. Smear the ink about on the paper until it makes a transparent tint. This thin ink smear will show you the intensity of the color approximately as it will print on paper.

It may not be quite what you want. You can lighten the ink by adding white to the original color, gray it with black, warm it with yellow, or cool it with blue or purple. Whenever you add ink to the original red, blue, or yellow, or whatever color ink you are using, always mix it thoroughly with the ink knife on the ink slab. Then smear some of it on white paper to ascertain the printing value of the color. Keep a record of the proportions. When you get a sample that you like you will be able to mix up a quantity large enough to print the entire color run. As you mix the inks, be sure to clean the ink knives thoroughly before taking ink from a can

of another color. An entire can of clean ink can be ruined by a dirty ink knife or a knife from which another color has not been cleaned. A little care in keeping the knives and the inks separate will prevent confusion when you mix the colors.

When you have mixed the red ink with white, black, blue, or some other color to get the tint or shade that you want, apply a small quantity of it on the red roller, and distribute the ink on the ink slab. Roll the roller until the ink is completely distributed. If it seems thin on the slab, add more ink to the roller to make certain that it will be capable of a full charge. However, do not be too lavish with the ink; too much is as bad as too little.

After the roller is inked, set it aside and wash the black ink from the stone with turpentine. Then wash the turpentine and gum from the stone with clean water. Take up any excess water with the sponge, and be sure that all traces of the turpentine have been removed. Then ink the stone with the red roller. Set the black roller aside for the time being. You will have to use it again if you want to keep the red stone for future use, after the day's printing is completed, or if you intend to prove another color stone the same day.

Ink the stone with three inkings, and be careful not to allow the water to dry out on the stone. Use the same care in damping a color stone that you use in damping a black-and-white stone. Take one proof, and then another. Compare the proof in color with the black proof. If you are satisfied that the red color is printing in full

intensity, proceed with the printing of the red stone. If the color does not please you, this is the time to add other colors to the ink to get the tint that you want. When the readjusted ink is ready, and you have tested it on paper, scrape the unwanted ink from the roller and the ink slab. Then apply the new ink to the roller and distribute it on the slab. After that has been done, wash the unwanted color from the stone with water and turpentine. Then wash the stone with clean water to remove all traces of the turpentine. Ink the stone with the new color, and take several proofs. If these new color proofs meet with your approval, you are ready to continue the printing. If the color still does not satisfy you, you will have to make another trial at mixing, going through the same procedure of scraping the roller and the ink slab and washing the undesired color from the stone, before inking it with the newly mixed color. You may have to make several trials before the color pleases you but it is worth the effort.

When the color proofs meet with your approval, you will be ready to print the complete run of the red stone. If you want twenty color prints, take at least thirty to forty red impressions. This is necessary as you may dislike the combination of red and blue inks when you print the second stone. While you may like the blue color, when it is printed on a blue proof, you may not like it as well when it is printed on the sheet that has the red impression. If you decide to change the blue, you may waste one or two more of the red impressions. The same thing may happen when you print the yellow color

on the red-blue impressions. You may also have a print
or two that may be off register and must be discarded,
and to compensate for these possible losses it is wise to
print more of the red impressions than the number of
prints you intend to have in the completed edition.

While you are printing, troubles may develop similar
to those that sometimes occur when you print a black-
and-white lithograph. However, you should be able to
foresee them while you are proving the color stones in
black ink and to take corrective measures then. The
most serious trouble that develops in printing a color
stone comes from overinking. That can be quickly rem-
edied by using less ink on the roller. If the stone has
taken too much ink, you can try to pull off the excess
ink by taking a proof without inking the stone. If that
does not work, you will have to wash out the stone with
water and turpentine, scrape the roller, and re-ink the
stone with less ink on the roller. If the stone persists in
taking an overload of color, it may be due to an under-
etched condition. This can be remedied by washing the
color ink from the stone with water and turpentine, and
then rolling it up in black ink. After that, dust rosin
powder on the stone and re-etch with a weak etch. Take
proofs in black ink; if they are all right, wash out the
black ink with water and turpentine, ink the stone with
color, and proceed with the printing.

If the color impressions do not appear to be printing
fully, the ink may be too stiff. Thin it with a drop or
two of No. 3 varnish. Be sure to mix the varnish thor-
oughly with the ink. Important! Never etch a color

stone while it is in color. Color inks are not very resistant to acid and the stone will probably be spoiled if any etch is applied to it. Always wash the color ink from the stone and reroll it in black ink to full strength before you attempt to re-etch a color stone.

THE REGISTER

As you print the red stone you will see that the crossed register lines have printed along with the design. The first square in the color indicator will also be in red, while the other three squares will be blank, although the outline of the color indicator will be in red. If you intend to print the blue stone the same day you print the red stone, place each red impression in the damp book, as you print it, in order to prevent the paper from drying out and thereby contracting. If you intend to print the blue stone another day, place the red impressions between dry blotters to allow them to dry out evenly. Then, before you print again, replace the red impressions in the damp press to permit the sheets of paper to expand to the size they were when the red impressions were taken. When the paper is ready, and you have mixed the blue ink and have the blue roller prepared for printing, you are ready to take the blue impressions.

You could take a red-blue impression by inking the blue stone and then placing the red impression over it, but, as you could not see through the paper, the resulting impression of the blue and red would probably be all out of register and therefore unfit for further print-

ing. The register marks are there to enable you to place the printing paper exactly over the parts to be printed in order to have each color in its designated position.

There are many methods of registering for color printing, most of them used commercially on offset presses. Most of these systems are unsuitable for creative printing on the hand press. There is, however, an efficient method of registering on stone that is simple and easy to use. It is known as the "window method" of registering. This is done by cutting a triangular hole in the printing paper on the register marks. When you lay the paper on the second, third, and fourth color stones you will be able to line up the register marks on the paper with those on the color stones by looking through the cutout windows, and in this way obtain a perfect register. This is how to do it.

At this point you have taken all the impressions that you will need from the red stone, and the next step is to take impressions on the same sheet of paper from the blue stone, to make a red and blue color impression on the paper. Before you can take the blue impressions successfully, the register windows will have to be cut on each sheet of paper, one on each side. Lay a sheet of the red color impression, face up, on a table so that one of the register crossed line marks is on your right hand and the other on your left. If you draw light pencil lines to connect the ends of the crossed lines, you will see that you have a square, crossed by two diagonal lines, forming four triangles. Number these triangles 1, 2, 3, and 4, beginning with the one at your uppermost right-hand

side (see drawing). Then take a ruler, and a sharp razor
blade and cut out triangle No. 1. Do this carefully as
the cut edges of the paper must fit exactly over the

THE RED IMPRESSION FROM THE RED STONE BEFORE THE
BLUE IMPRESSION IS TAKEN

A-1. The cutout window in triangle No. 4 on the left-hand side of the
paper.
A-2. The cutout window in triangle No. 1 on the right-hand side of the
paper.
 B. The red color in the color indicator squares.
 C. The distribution of color on the red impression.

crossed-line register marks on the remaining three color
stones. When you have done this to all the red impres-
sion sheets, you are ready to cut the windows on the
register marks on the left-hand side of the paper. As
before, draw light pencil marks to connect the ends of

the crossed lines to make a square that will be crossed by two diagonals to make four triangles. Number these triangles as you did the first ones, but this time you are to cut away triangle No. 4, the one on the uppermost left-hand side. Cut similar windows in all the red impression sheets, and then you will be ready to take the blue impressions.

THE BLUE COLOR STONE

Before you actually take the first blue impression, it is advisable to practice locating the register marks on the stone through the windows on the paper. As the paper will go face down on the stone, you will not have the register marks on the back of the paper. That is the reason for the windows. A good way to place the paper on the stone is to hold the sheet in both hands, between your forefingers and thumbs. Rest your other fingers on the edges of the stone, and move the paper until you can see the register lines on the stone coincide with the cut edges of the window. Then lower your right hand and set that side of the paper on the stone. When you are certain that the register marks on the stone and on the paper are in position, hold the right-hand side of the paper firmly in place and then lower the left-hand side onto the stone. If you have made the register marks carefully and have cut the windows exactly, all the marks will meet, and the paper will be in perfect register with the stone.

Be careful when you place the backing over the paper. Hold the paper in place with one hand and put on the

backing with the other. Do the same thing when you place the tympan over the backing. Hold the tympan firmly in place until it is under the scraper and you apply the printing pressure. After the stone has been run through the press, pull the bed back to its original position and carefully lift the tympan and the backing. Lift the impression from the stone and damp the stone before you examine the impression. If the paper has not slipped, you should have a red and blue impression with the colors in perfect register. The register lines will have the blue color printed exactly over the red, and the blue color on the color indicator will be lined up directly under the red square, exactly within the limits of its own square.

Sometimes when you are printing in color the edges of the stone will pick up ink from the roller. As the color will print on the paper, you can keep the edges clean by removing the ink with snake slip and water and by etching the cleaned places, taking care not to get any of the etch on the inked parts of the design. Unwanted color on the edges of the paper will give a dirty appearance to the finished print and should be eliminated.

Before you continue printing the rest of the blue impressions, it would be a good plan to examine the red impressions that are in the damp press. Be sure that the edges of the paper are as damp as the body and that the sheets are not too wet or too dry. This is important because, besides having the paper slip while you are running the impression on the second, third, or fourth color stones, paper that is not damped properly is the chief

cause of the impressions printing off register. If the paper is too dry it will expand when damp. If paper is too wet it will stretch and sometimes break. In either case no true register will be possible.

Printing with damp paper is more troublesome and requires more care than printing with dry paper. You can help to overcome undue expansion of the paper by giving it a simple stretching treatment before you damp it preparatory to the first printing. This can be done by placing a sheet of printing paper on a clean stone and then running it through the press under normal pressure, to stretch it. Do not forget to place clean backing over the paper to prevent soiling. While it is, of course, possible to print from stone with dry paper, a creative lithograph printed on damp paper always achieves a greater delicacy of tone and makes a finer print.

However, you can print on dry paper if you like. You might try both and see which gives your own work the best results. If you print with damp paper, the paper should be a heavy stock to withstand the repeated printings and dampings without tearing. The Rives paper in the heavy weight is excellent for color printing, but plate papers designed for use in chart and book printing are good too. Ask for printing samples from a paper supply house, as in any case you will probably like to experiment with all sorts of paper to find those best suited for your own work.

If you do not have time to complete the printing of the blue impressions, or any of the other color stones for which you have mixed a batch of color ink, and you

want to lay the color stone aside for a day or so, this is what to do.

First, scrape all the unused, mixed color ink from the ink slab with a clean ink knife and place it in a small glass jar that has a tightly fitting cover. Then fill the jar with clean cool water to cover all the ink. Place the cover securely on the jar and the ink will not dry out for a few days. If you allow the ink to stand on the slab or in a receptacle that gives access to air, the ink will dry quickly and become unusable. Then you will have to mix another batch, which will be quite a problem, as it is difficult to get an exact match for the color. The better plan in printing is to run the complete number of color impressions when you have the ink exactly the color you want.

When you have set the ink aside in the tightly covered jar, the next step is to wash the color from the stone with water and turpentine. After the stone is completely cleaned of all traces of the color, ink it with black ink, until the design is up to full strength. When that is done, dust rosin powder on the stone and apply a fresh solution of gum arabic. Dry the gum arabic and you can then set the stone aside until you are again ready to print. Scrape the ink from the black roller and place the roller in its rack. Then scrape the color roller and clean it thoroughly with turpentine or kerosene. Wrap it in wax paper and put it in the roller rack. Scrape and clean the black ink slab as well as the color ink slab.

When you are ready to print again, pour the water off the color ink, and then place the ink on the color

ink slab with a clean ink knife. Mix fresh black ink and place it on its ink slab. Then get both rollers into printing condition by first scraping them to remove any of the old ink that might have been overlooked. You are now ready to roll them with their respective inks. After the rollers are inked, wash off the old gum from the stone and apply a fresh gum arabic solution. Dry this solution and wash the old black ink from the stone with turpentine. Then wash the turpentine and gum from the stone with clean water and ink the stone with fresh black ink. Continue to ink the stone with black ink until it has a full charge, and take proofs in the usual way.

When the black proofs are right, check them with the black proofs that you made when you first proved this color stone. When the new proofs match the old ones, wash the black ink from the stone with water and turpentine and, when all traces of the black ink and turpentine have been removed, ink the stone with the color ink, in this case the blue. Take two or three proofs, until the new proofs show that the stone is printing properly, and then continue the printing on the red impressions. When you have finished printing the blue stone, it is a good plan to wash the blue ink from the stone and re-ink it in black. Lay it aside after you have dusted it with rosin powder and applied gum arabic solution. This should be done with all the color stones, until the color lithograph is completed and you are satisfied with the result.

As you take the blue impressions, replace the paper in

the damp press if you intend to print the yellow stone the same day. If you are not going to print the yellow stone until another day, put the red-blue impressions in dry blotters. Before you get ready to print again, the sheets will have to be damped in the usual way.

THE YELLOW COLOR STONE

The yellow stone is treated in the same way as the red and blue stones, by first washing off the dried etch with water, then applying a fresh gum arabic solution and drying it. Wash out the crayon with turpentine and remove the turpentine and gum from the stone with clean water. After this is done, ink the stone with black ink and take the black proofs. When they are right and corrections, if any, have been made and etched, the black ink is washed from the stone with water and turpentine, and the stone is inked with the yellow ink. When the yellow proofs are printing at full strength, you will be ready to take the yellow color on the red-blue impressions. Examine the paper to see that it is evenly damped. Make certain that it is not too wet or too dry. As the cutout windows are on all the sheets, registering the paper to the yellow stone is done exactly as it was for the blue stone. When the three color impressions are taken, you will see that the crossed register marks will have the three colors superimposed, one on the other, and that the color indicator will have three of the four squares exactly filled with each one of the colors. If any troubles develop in printing the yellow

stone, be sure to wash the color from the stone and roll it in black ink before attempting any corrections.

THE BLACK COLOR STONE

When the red-blue-yellow impressions have all been taken, the remaining black stone is ready for printing. As this stone is to be printed with the regular black crayon ink, all that is necessary for its preparation is the usual methods of proving any black-and-white lithograph. When the proofs show that the stone is printing well, you will be ready to take the black impressions. Registering and printing this stone is done the same way as the registering and printing of the other color stones. As you take each impression, it will be a completed color lithograph and should be put to dry between stacked blotters to ensure flat even prints. After the prints are dry, you can trim the paper to eliminate the register marks and the windows. If the completed edition of the color lithograph pleases you, you are ready to grain the stones in preparation for your next lithograph. However, it is probable that you may wish to improve your lithograph by taking other prints, either by changing the tints of the colors you have been using or by means of an entirely different color arrangement. If you have laid each stone away for future use, after printing, you have only to mix new colors and to take another edition.

Sometimes when you are color printing you may find it worth your while to take a series of progressive prints as a record of the various steps in the making of your

color lithograph. This is done by making (1) a black impression of the red stone and then (2) a red impression of the red stone.

The second series of progressive prints will begin with the (3) black impression of the blue stone, followed by (4) the blue impression and then (5) by the red-blue impression.

The third stone will give you (6) a black impression of the yellow stone, (7) a yellow impression of the yellow stone, and finally (8) a red-blue-yellow impression of the three color stones.

The black stone proof will contribute (9) a black impression to the set of progressive prints and (10) the completed lithograph in four colors will end the series. A set of progressive prints is interesting for reference when you plan new lithographs in color, as they can be utilized to suggest possible changes in your technique of drawing on the color stones.

METAL PLATE COLOR PRINTING

Color lithographs can be drawn on and printed from metal plates. Except for the difference in methods of etching, using phosphoric or other acids instead of nitric, both zinc and aluminum are treated in exactly the same way as described for drawing and printing a color lithograph on stone. You will need five plates if you are planning a lithograph for four color plates. One plate will be used as the key plate, and the other four will be used for the red, blue, yellow, and black plates. The tracing of the color sketch is placed on the

key plate, as described for stone in Chapter XIII. The key plate register marks and color indicator squares are to be drawn as previously directed.

After the color plates are drawn in crayon or tusche they are to be etched according to the directions given in Chapter XII, "Zinc and Aluminum Plates."

For proving and printing the key plate and making the offset transfers, follow the directions given for proving, printing the keystone and making the offset transfers from impressions taken from the keystone.

A color plate must first be inked in black and black proofs taken before the plate is inked in color. As with stone, if any corrections are necessary they are to be made while the plate is inked with black ink. When the black proofs, made from the color plate, are satisfactory, wash the black ink from the plate with water and turpentine, and ink with color. If you want to save the plate after printing or between printing sessions, be sure to wash the color ink from the plate with water and turpentine, and ink it in black before you dust it with rosin powder and apply the gum arabic solution. Cutting the register windows on the paper and printing the color plates is accomplished exactly as described in the procedure indicated for registering and printing on stone.

If you have quite finished with all the color plates after your entire edition has been taken, you might like to have the plates regrained so that you can use them over again. Your lithograph supply house can arrange to have this done for you at a modest cost. It usually is

less expensive to save the plates until you have a dozen or more, before sending them off to be regrained. The regrained plates will be just as serviceable as new ones, and they can, of course, be regrained more than once.

You may like to refer to the following books for additional reading on the subject of color lithographs:

Handbook of Lithography, by David Cumming, pp. 80-92, 147-185. Adam and Charles Black, Ltd., London, 1919.

The Grammar of Lithography, by W. D. Richmond, pp. 144-187. Weyman and Sons, London, 1886.

XV

Conclusion

The beauty of a creative lithograph, whether in black and white or in color, is primarily dependent on the fine art merit of the print. The vision of the artist and his technical skill in setting down his ideas to convey his reaction of thought to the life about him in a visual graphic medium, regardless of subject matter, is the important thing in creative art, no matter what medium of expression is utilized. When you draw on paper, paint with water color or oil, or use any of the other direct media of creative endeavor, the completed work needs no amplification before it can be exhibited and shown to the public.

The lithograph, made on stone or metal plate, must be taken off by the process of printing and put on paper before it can function as a completed work of art. This process of printing is not merely a method of reproducing an original drawing, that is complete in itself, in order to obtain a number of duplicates of the same drawing. It is printmaking, which is an entirely different matter. Lithography can be used commercially to re-

produce exactly an original drawing in facsimile, but the creative lithograph is much more than that. The artist uses the grain of the stone or metal plate to get in the print textural qualities that are not possible through any other medium, and the skill with which he prints the lithograph determines the beauty of the completed work. For the artist, lithography combines the activity of creative expression with the exactness of a craftman's creative skill to make possible the full use of all the artist's visual and sensory faculties.

There is tradition in creative lithography, not only in the works that have been produced by the masters of the medium but also in those produced by the artists who print their own works. For the student, artist, educator, and layman who wishes to evaluate the works of others in the field of creative lithography, it is suggested that the prints of artists, from the time of Senefelder's invention of the process to those of the present day, be studied. Look at these prints, from the viewpoints of design, composition, and textural quality of the print. Try to see how the artist achieved his purpose by the technical methods of rubbing, scraping, tusche accent, and building up the tones with the crayon.

Practically all libraries, colleges, museums, and art dealers have collections of original lithographs, along with other examples of printmaking. Look through the collections until you see a lithograph that you like. Do not pass it by quickly. Study it carefully and practically redraw it in your mind, not for the sake of copying it or for making the artist's technique your own, but to

appreciate the limitless possibilities of this creative medium. If you carefully examine the lithographs of other artists before you make your own, you will be stimulated to greater efforts. When you look at these same works after you have made and printed one or two of your own lithographs, your appreciation of lithography, as a creative medium, will be augmented by your own experience in this field of creative expression.

Appendix

MATERIALS USED IN CREATIVE LITHOGRAPHY

LITHOGRAPH SUPPLY HOUSE:

A geared lithographic proof press. Bed size 24 x 36 inches.

Box wood scrapers (see text).

Strips of scraper leather (see text).

One sheet red pressboard (for tympan).

Lithographic hand roller of grained leather (recommended size 12 to 14 inches for black and color).

Leather handle grips for rollers.

Leather hand guards for rollers.

Two or more lithograph stones, blue-gray in color, size 12 x 16 inches.

Ink slab, size 16 x 20 inches. (This can be a poor quality lithograph stone, marble, slate, or plate glass. Stone preferred.)

One Schumacher brick or pumice stone.

One pound French chalk, powdered.

One pound rosin, powdered.

One pound red chalk powder for transfer offsets.

Two Cuban sheep's-wool sponges.

One pint liquid asphaltum for metal plates (see text).

One dozen snake slips.

One Rubberset acid brush. Size 2 inches.

Lithograph varnish. One pint each of No. oo, No. 3, No. 4, and No. 7.

Six pounds gum arabic.

Lithograph crayons and pencils.

Red conté chalk crayons.

Chamois skin for rubbed tones.

Scraps of roller felt for rubbed tones.

Lithograph tusche (drawing ink).

One stick of lithographic rubbing ink for color stones.

One pound can crayon ink for printing.

Color inks for printing color lithographs.

Sea sand, flint and quartz powders for graining stones.

Carborundum powder for graining stones. One pound each of No. 180, No. 220 and No. F.

PAPER SUPPLY HOUSE:

Wove printing papers.

Coated printing paper for offset transfers.

Fifty white porcelain blotters (heavyweight). Size 19 x 24 inches.

Mat board.

WORKMAN'S SUPPLY STORE:

One shop apron.

HARDWARE STORE:

One carpenter's square, 12 x 24 inches (steel).

Plate glass or sheet metal for weighting sheets stacked between blotters.

DRUGSTORE:

Alum powder.

One pound nitric acid, U.S.C.P.

One ounce phosphoric acid.

One 6-ounce graduate.

One ounce oxalic acid crystals.

Two 6-inch pipettes with rubber nipples.

One ounce eugenol or carbolic acid.

Alcohol and pitch for use in Hullmandel's process (see text).

TEN-CENT STORE:

Two 2-quart shallow pans, 8 inches in diameter.

Two 1-pint Mason jars.

One pound automobile lubricating grease.

One 2-inch brush for applying grease.

One bottle machine oil with applicator.

One pair rubber gloves.

Several yards of cheesecloth.

One 3-inch putty knife or wall scraper.
Two silver-plated table knives for applying ink and scraping the rollers (ink spatulas can be ordered from a lithograph supply house).
One dozen hard-backed, single-edged razor blades.

Home Construction:
Clean soft rags, such as old sheets.
Hand fan.
Stone graining table.
Shallow dish for holding acid solution.
Ink knife rack.
Damp press for paper.

WHERE TO GET MATERIALS

General Supplies
J. H. & G. B. Siebold, Inc., 150 Varick St., New York, N. Y.
Roberts & Porter, 4140 West Victoria St., Chicago, Ill.

Lithograph Inks[1]
Gaetjens, Berger & Wirth, Inc., Gair Building, 35 York St., Brooklyn, N. Y.
General Printing Ink Co., division of Sun Chemical Corp., 750 Third Ave., New York, N. Y.

Lithograph Crayons[2]
Wm. Korn, Inc., 260 West St., New York, N. Y.

Printing Paper[3]
Strathmore Paper Company, West Springfield, Mass.
Andrews-Nelson-Whitehead, Inc., 7 Laight St., New York, N. Y.

[1] The firms listed under general supplies stock lithographic inks.
[2] The firms listed under general supplies stock lithograph crayons.
[3] The firms listed under general supplies stock Chinese India paper.

Lindenmeyr Schlosser Co., 53rd Ave. at 11th St., Long Island City, N. Y.

MAT BOARD

Chas. T. Bainbridge's Sons, 20 Cumberland St., Brooklyn, N. Y.

INDEX

A CATALOGUE OF SELECTED DOVER BOOKS
IN ALL FIELDS OF INTEREST

A CATALOGUE OF SELECTED DOVER BOOKS
IN ALL FIELDS OF INTEREST

THE NOTEBOOKS OF LEONARDO DA VINCI, edited by J.P. Richter. Extracts from manuscripts reveal great genius; on painting, sculpture, anatomy, sciences, geography, etc. Both Italian and English. 186 ms. pages reproduced, plus 500 additional drawings, including studies for Last Supper, Sforza monument, etc. 860pp. 7⅞ x 10¾. USO 22572-0, 22573-9 Pa., Two vol. set $15.90

ART NOUVEAU DESIGNS IN COLOR, Alphonse Mucha, Maurice Verneuil, Georges Auriol. Full-color reproduction of Combinaisons ornamentales (c. 1900) by Art Nouveau masters. Floral, animal, geometric, interlacings, swashes — borders, frames, spots — all incredibly beautiful. 60 plates, hundreds of designs. 9⅜ x 8¹/₁₆ . 22885-1 Pa. $4.00

GRAPHIC WORKS OF ODILON REDON. All great fantastic lithographs, etchings, engravings, drawings, 209 in all. Monsters, Huysmans, still life work, etc. Introduction by Alfred Werner. 209pp. 9⅛ x 12¼. 21996-8 Pa. $6.00

EXOTIC FLORAL PATTERNS IN COLOR, E.-A. Seguy. Incredibly beautiful full-color pochoir work by great French designer of 20's. Complete Bouquets et frondaisons, Suggestions pour étoffes. Richness must be seen to be believed. 40 plates containing 120 patterns. 80pp. 9⅜ x 12¼. 23041-4 Pa. $6.00

SELECTED ETCHINGS OF JAMES A. McN. WHISTLER, James A. McN. Whistler. 149 outstanding etchings by the great American artist, including selections from the Thames set and two Venice sets, the complete French set, and many individual prints. Introduction and explanatory note on each print by Maria Naylor. 157pp. 9⅜ x 12¼. 23194-1 Pa. $5.00

VISUAL ILLUSIONS: THEIR CAUSES, CHARACTERISTICS, AND APPLICATIONS, Matthew Luckiesh. Thorough description, discussion; shape and size, color, motion; natural illusion. Uses in art and industry. 100 illustrations. 252pp.
21530-X Pa. $2.50

TEN BOOKS ON ARCHITECTURE, Vitruvius. The most important book ever written on architecture. Early Roman aesthetics, technology, classical orders, site selection, all other aspects. Stands behind everything since. Morgan translation. 331pp.
20645-9 Pa. $3.50

THE CODEX NUTTALL. A PICTURE MANUSCRIPT FROM ANCIENT MEXICO, as first edited by Zelia Nuttall. Only inexpensive edition, in full color, of a pre-Columbian Mexican (Mixtec) book. 88 color plates show kings, gods, heroes, temples, sacrifices. New explanatory, historical introduction by Arthur G. Miller. 96pp. 11⅜ x 8½. 23168-2 Pa. $7.50

150 MASTERPIECES OF DRAWING, edited by Anthony Toney. 150 plates, early 15th century to end of 18th century; Rembrandt, Michelangelo, Dürer, Fragonard, Watteau, Wouwerman, many others. 150pp. 8⅜ x 11¼. 21032-4 Pa. $4.00

THE GOLDEN AGE OF THE POSTER, Hayward and Blanche Cirker. 70 extraordinary posters in full colors, from Maîtres de l'Affiche, Mucha, Lautrec, Bradley, Cheret, Beardsley, many others. 9⅜ x 12¼. 22753-7 Pa. $4.95
21718-3 Clothbd. $7.95

SIMPLICISSIMUS, selection, translations and text by Stanley Appelbaum. 180 satirical drawings, 16 in full color, from the famous German weekly magazine in the years 1896 to 1926. 24 artists included: Grosz, Kley, Pascin, Kubin, Kollwitz, plus Heine, Thöny, Bruno Paul, others. 172pp. 8½ x 12¼. 23098-8 Pa. $5.00
23099-6 Clothbd. $10.00

THE EARLY WORK OF AUBREY BEARDSLEY, Aubrey Beardsley. 157 plates, 2 in color: Manon Lescaut, Madame Bovary, Morte d'Arthur, Salome, other. Introduction by H. Marillier. 175pp. 8½ x 11. 21816-3 Pa. $4.00

THE LATER WORK OF AUBREY BEARDSLEY, Aubrey Beardsley. Exotic masterpieces of full maturity: Venus and Tannhäuser, Lysistrata, Rape of the Lock, Volpone, Savoy material, etc. 174 plates, 2 in color. 176pp. 8½ x 11. 21817-1 Pa. $4.00

DRAWINGS OF WILLIAM BLAKE, William Blake. 92 plates from Book of Job, Divine Comedy, Paradise Lost, visionary heads, mythological figures, Laocoön, etc. Selection, introduction, commentary by Sir Geoffrey Keynes. 178pp. 8½ x 11. 22303-5 Pa. $3.50

LONDON: A PILGRIMAGE, Gustave Doré, Blanchard Jerrold. Squalor, riches, misery, beauty of mid-Victorian metropolis; 55 wonderful plates, 125 other illustrations, full social, cultural text by Jerrold. 191pp. of text. 8⅛ x 11. 22306-X Pa. $5.00

THE COMPLETE WOODCUTS OF ALBRECHT DÜRER, edited by Dr. W. Kurth. 346 in all: Old Testament, St. Jerome, Passion, Life of Virgin, Apocalypse, many others. Introduction by Campbell Dodgson. 285pp. 8½ x 12¼. 21097-9 Pa. $6.00

THE DISASTERS OF WAR, Francisco Goya. 83 etchings record horrors of Napoleonic wars in Spain and war in general. Reprint of 1st edition, plus 3 additional plates. Introduction by Philip Hofer. 97pp. 9⅜ x 8¼. 21872-4 Pa. $3.00

ENGRAVINGS OF HOGARTH, William Hogarth. 101 of Hogarth's greatest works: Rake's Progress, Harlot's Progress, Illustrations for Hudibras, Midnight Modern Conversation, Before and After, Beer Street and Gin Lane, many more. Full commentary. 256pp. 11 x 14. 22479-1 Pa. $7.00
23023-6 Clothbd. $13.50

PRIMITIVE ART, Franz Boas. Great anthropologist on ceramics, textiles, wood, stone, metal, etc.; patterns, technology, symbols, styles. All areas, but fullest on Northwest Coast Indians. 350 illustrations. 378pp. 20025-6 Pa. $3.75

THE ART DECO STYLE, ed. by Theodore Menten. Furniture, jewelry, metalwork, ceramics, fabrics, lighting fixtures, interior decors, exteriors, graphics from pure French sources. Best sampling around. Over 400 photographs. 183pp. 8⅜ x 11¼.
22824-X Pa. $4.00

THE GENTLEMAN AND CABINET MAKER'S DIRECTOR, Thomas Chippendale. Full reprint, 1762 style book, most influential of all time; chairs, tables, sofas, mirrors, cabinets, etc. 200 plates, plus 24 photographs of surviving pieces. 249pp. 9⅞ x 12¾.
21601-2 Pa. $6.00

PINE FURNITURE OF EARLY NEW ENGLAND, Russell H. Kettell. Basic book. Thorough historical text, plus 200 illustrations of boxes, highboys, candlesticks, desks, etc. 477pp. 7⅞ x 10¾.
20145-7 Clothbd. $12.50

ORIENTAL RUGS, ANTIQUE AND MODERN, Walter A. Hawley. Persia, Turkey, Caucasus, Central Asia, China, other traditions. Best general survey of all aspects: styles and periods, manufacture, uses, symbols and their interpretation, and identification. 96 illustrations, 11 in color. 320pp. 6⅛ x 9¼.
22366-3 Pa. $5.00

DECORATIVE ANTIQUE IRONWORK, Henry R. d'Allemagne. Photographs of 4500 iron artifacts from world's finest collection, Rouen. Hinges, locks, candelabra, weapons, lighting devices, clocks, tools, from Roman times to mid-19th century. Nothing else comparable to it. 420pp. 9 x 12.
22082-6 Pa. $8.50

THE COMPLETE BOOK OF DOLL MAKING AND COLLECTING, Catherine Christopher. Instructions, patterns for dozens of dolls, from rag doll on up to elaborate, historically accurate figures. Mould faces, sew clothing, make doll houses, etc. Also collecting information. Many illustrations. 288pp. 6 x 9. 22066-4 Pa. $3.00

ANTIQUE PAPER DOLLS: 1915-1920, edited by Arnold Arnold. 7 antique cut-out dolls and 24 costumes from 1915-1920, selected by Arnold Arnold from his collection of rare children's books and entertainments, all in full color. 32pp. 9¼ x 12¼.
23176-3 Pa. $2.00

ANTIQUE PAPER DOLLS: THE EDWARDIAN ERA, Epinal. Full-color reproductions of two historic series of paper dolls that show clothing styles in 1908 and at the beginning of the First World War. 8 two-sided, stand-up dolls and 32 complete, two-sided costumes. Full instructions for assembling included. 32pp. 9¼ x 12¼.
23175-5 Pa. $2.00

A HISTORY OF COSTUME, Carl Köhler, Emma von Sichardt. Egypt, Babylon, Greece up through 19th century Europe; based on surviving pieces, art works, etc. Full text and 595 illustrations, including many clear, measured patterns for reproducing historic costume. Practical. 464pp. 21030-8 Pa. $4.00

EARLY AMERICAN LOCOMOTIVES, John H. White, Jr. Finest locomotive engravings from late 19th century: historical (1804-1874), main-line (after 1870), special, foreign, etc. 147 plates. 200pp. 11⅜ x 8¼. 22772-3 Pa. $3.50

DECORATIVE ALPHABETS AND INITIALS, edited by Alexander Nesbitt. 91 complete alphabets (medieval to modern), 3924 decorative initials, including Victorian novelty and Art Nouveau. 192pp. 7¾ x 10¾. 20544-4 Pa. $4.00

CALLIGRAPHY, Arthur Baker. Over 100 original alphabets from the hand of our greatest living calligrapher: simple, bold, fine-line, richly ornamented, etc. — all strikingly original and different, a fusion of many influences and styles. 155pp. 11⅜ x 8¼. 22895-9 Pa. $4.50

MONOGRAMS AND ALPHABETIC DEVICES, edited by Hayward and Blanche Cirker. Over 2500 combinations, names, crests in very varied styles: script engraving, ornate Victorian, simple Roman, and many others. 226pp. 8⅛ x 11.
 22330-2 Pa. $5.00

THE BOOK OF SIGNS, Rudolf Koch. Famed German type designer renders 493 symbols: religious, alchemical, imperial, runes, property marks, etc. Timeless. 104pp. 6⅛ x 9¼. 20162-7 Pa. $1.75

200 DECORATIVE TITLE PAGES, edited by Alexander Nesbitt. 1478 to late 1920's. Baskerville, Dürer, Beardsley, W. Morris, Pyle, many others in most varied techniques. For posters, programs, other uses. 222pp. 8⅜ x 11¼. 21264-5 Pa. **$5.00**

DICTIONARY OF AMERICAN PORTRAITS, edited by Hayward and Blanche Cirker. 4000 important Americans, earliest times to 1905, mostly in clear line. Politicians, writers, soldiers, scientists, inventors, industrialists, Indians, Blacks, women, outlaws, etc. Identificatory information. 756pp. 9¼ x 12¾. 21823-6 Clothbd. $30.00

ART FORMS IN NATURE, Ernst Haeckel. Multitude of strangely beautiful natural forms: Radiolaria, Foraminifera, jellyfishes, fungi, turtles, bats, etc. All 100 plates of the 19th century evolutionist's Kunstformen der Natur (1904). 100pp. 9⅜ x 12¼. 22987-4 Pa. $4.00

DECOUPAGE: THE BIG PICTURE SOURCEBOOK, Eleanor Rawlings. Make hundreds of beautiful objects, over 550 florals, animals, letters, shells, period costumes, frames, etc. selected by foremost practitioner. Printed on one side of page. 8 color plates. Instructions. 176pp. 9³/₁₆ x 12¼. 23182-8 Pa. $5.00

AMERICAN FOLK DECORATION, Jean Lipman, Eve Meulendyke. Thorough coverage of all aspects of wood, tin, leather, paper, cloth decoration — scapes, humans, trees, flowers, geometrics — and how to make them. Full instructions. 233 illustrations, 5 in color. 163pp. 8⅜ x 11¼. 22217-9 Pa. $3.95

WHITTLING AND WOODCARVING, E.J. Tangerman. Best book on market; clear, full. If you can cut a potato, you can carve toys, puzzles, chains, caricatures, masks, patterns, frames, decorate surfaces, etc. Also covers serious wood sculpture. Over 200 photos. 293pp. 20965-2 Pa. $3.00

THE MAGIC MOVING PICTURE BOOK, Bliss, Sands & Co. The pictures in this book move! Volcanoes erupt, a house burns, a serpentine dancer wiggles her way through a number. By using a specially ruled acetate screen provided, you can obtain these and 15 other startling effects. Originally "The Motograph Moving Picture Book." 32pp. 8¼ x 11. 23224-7 Pa. $1.75

STRING FIGURES AND HOW TO MAKE THEM, Caroline F. Jayne. Fullest, clearest instructions on string figures from around world: Eskimo, Navajo, Lapp, Europe, more. Cats cradle, moving spear, lightning, stars. Introduction by A.C. Haddon. 950 illustrations. 407pp. 20152-X Pa. $3.50

PAPER FOLDING FOR BEGINNERS, William D. Murray and Francis J. Rigney. Clearest book on market for making origami sail boats, roosters, frogs that move legs, cups, bonbon boxes. 40 projects. More than 275 illustrations. Photographs. 94pp. 20713-7 Pa. $1.25

INDIAN SIGN LANGUAGE, William Tomkins. Over 525 signs developed by Sioux, Blackfoot, Cheyenne, Arapahoe and other tribes. Written instructions and diagrams: how to make words, construct sentences. Also 290 pictographs of Sioux and Ojibway tribes. 111pp. 6⅛ x 9¼. 22029-X Pa. $1.50

BOOMERANGS: HOW TO MAKE AND THROW THEM, Bernard S. Mason. Easy to make and throw, dozens of designs: cross-stick, pinwheel, boomabird, tumblestick, Australian curved stick boomerang. Complete throwing instructions. All safe. 99pp. 23028-7 Pa. $1.75

25 KITES THAT FLY, Leslie Hunt. Full, easy to follow instructions for kites made from inexpensive materials. Many novelties. Reeling, raising, designing your own. 70 illustrations. 110pp. 22550-X Pa. $1.25

TRICKS AND GAMES ON THE POOL TABLE, Fred Herrmann. 79 tricks and games, some solitaires, some for 2 or more players, some competitive; mystifying shots and throws, unusual carom, tricks involving cork, coins, a hat, more. 77 figures. 95pp. 21814-7 Pa. $1.25

WOODCRAFT AND CAMPING, Bernard S. Mason. How to make a quick emergency shelter, select woods that will burn immediately, make do with limited supplies, etc. Also making many things out of wood, rawhide, bark, at camp. Formerly titled Woodcraft. 295 illustrations. 580pp. 21951-8 Pa. $4.00

AN INTRODUCTION TO CHESS MOVES AND TACTICS SIMPLY EXPLAINED, Leonard Barden. Informal intermediate introduction: reasons for moves, tactics, openings, traps, positional play, endgame. Isolates patterns. 102pp. USO 21210-6 Pa. $1.35

LASKER'S MANUAL OF CHESS, Dr. Emanuel Lasker. Great world champion offers very thorough coverage of all aspects of chess. Combinations, position play, openings, endgame, aesthetics of chess, philosophy of struggle, much more. Filled with analyzed games. 390pp. 20640-8 Pa. $4.00

CATALOGUE OF DOVER BOOKS

COOKIES FROM MANY LANDS, Josephine Perry. Crullers, oatmeal cookies, chaux au chocolate, English tea cakes, mandel kuchen, Sacher torte, Danish puff pastry, Swedish cookies — a mouth-watering collection of 223 recipes. 157pp.
22832-0 Pa. $2.00

ROSE RECIPES, Eleanour S. Rohde. How to make sauces, jellies, tarts, salads, pot-pourris, sweet bags, pomanders, perfumes from garden roses; all exact recipes. Century old favorites. 95pp.
22957-2 Pa. $1.25

"OSCAR" OF THE WALDORF'S COOKBOOK, Oscar Tschirky. Famous American chef reveals 3455 recipes that made Waldorf great; cream of French, German, American cooking, in all categories. Full instructions, easy home use. 1896 edition. 907pp. 6⅝ x 9⅜.
20790-0 Clothbd. $15.00

JAMS AND JELLIES, May Byron. Over 500 old-time recipes for delicious jams, jellies, marmalades, preserves, and many other items. Probably the largest jam and jelly book in print. Originally titled May Byron's Jam Book. 276pp.
USO 23130-5 Pa. $3.00

MUSHROOM RECIPES, André L. Simon. 110 recipes for everyday and special cooking. Champignons à la grecque, sole bonne femme, chicken liver croustades, more; 9 basic sauces, 13 ways of cooking mushrooms. 54pp.
USO 20913-X Pa. $1.25

FAVORITE SWEDISH RECIPES, edited by Sam Widenfelt. Prepared in Sweden, offers wonderful, clearly explained Swedish dishes: appetizers, meats, pastry and cookies, other categories. Suitable for American kitchen. 90 photos. 157pp.
23156-9 Pa. $2.00

THE BUCKEYE COOKBOOK, Buckeye Publishing Company. Over 1,000 easy-to-follow, traditional recipes from the American Midwest: bread (100 recipes alone), meat, game, jam, candy, cake, ice cream, and many other categories of cooking. 64 illustrations. From 1883 enlarged edition. 416pp.
23218-2 Pa. $4.00

TWENTY-TWO AUTHENTIC BANQUETS FROM INDIA, Robert H. Christie. Complete, easy-to-do recipes for almost 200 authentic Indian dishes assembled in 22 banquets. Arranged by region. Selected from Banquets of the Nations. 192pp.
23200-X Pa. $2.50

Prices subject to change without notice.
Available at your book dealer or write for free catalogue to Dept. GI, Dover Publications, Inc., 180 Varick St., N.Y., N.Y. 10014. Dover publishes more than 150 books each year on science, elementary and advanced mathematics, biology, music, art, literary history, social sciences and other areas.